ENFIELD
THROUGH TIME
Stephen Sellick

AMBERLEY PUBLISHING

Front cover images:
Market Place, Enfield
The Market Cross was only a year old when this engraving was done in 1827. The cross was replaced by the market house in 1904. Behind the cross is the King's Head public house that is first recorded in 1516, current since 1899, which closed on 15 December 2007 and re-opened 4 November 2010. Then is the fourteenth-century St Andrew's Church. The major buildings are The Greyhound public house and Barclays Bank. The Greyhound's earliest record is on a 1364 Enfield Parochial Trust document. The pub ceased trading in the 1860s and the buildings had various uses until it was re-placed in 1897 by the bank.

Back cover images:
Theobald's Estate, Waltham Cross
This gate first stood where the Strand meets Fleet Street, replacing a wooden structure in 1670. It was dismantled in 1878, but not erected as the northern gate to the estate until 1888. The plaque explains the viewing from this point within the estate you used to see (opposite way to the other picture) before it was moved and Paternoster Square, City of London, where it was officially opened on the 10 November 2004.

First published 2011

Amberley Publishing
Cirencester Road, Chalford,
Stroud, Gloucestershire, GL6 8PE

www.amberley-books.com

Copyright © Stephen Sellick, 2011

The right of Stephen Sellick to be identified as the Author of this work has been asserted in accordance with the Copyrights, Designs and Patents Act 1988.

ISBN 978 1 84868 639 7

British Library Cataloguing in Publication Data.
A catalogue record for this book is available from the British Library.

Typeset in 9.5pt on 12pt Celeste.
Typesetting by Amberley Publishing.
Printed in the UK.

Introduction

The first picture postcard was produced in Austria in October 1869 and the first in Great Britain in September 1894. The earliest Enfield postmarked picture postcard I have is dated September 1900. Most of the original pictures in this book are from postcards produced during the ten years before the First World War. For this book I considered 152 locations. I included in the 152 possibilites for the book some unlikely subjects, as well as the very likely ones. A few of these unlikely ones turned out to be interesting enough to use in the book. The number considered was cut down by cases that were either impossible to take or not worth taking in 2010, a large percentage of these caused by trees and so on that were blocking the view wanted.

During the Tudor period (1485–1603) the Vestries increasingly became in control of local government. The earliest Enfield Vestry records date from 1671. The Poor Law Amendment Act of 1834 reduced the Vestries powers and the Public Health Act of 1848 took their remaining responsibilities. From 1850 the directly elected Enfield Local Board of Health was in control of local matters. Local government was further changed by the Local Government Act of 1894, under which in 1895 Enfield LBH became Enfield Urban District Council. The next change was as from 23 May 1955 when Enfield UDC received its royal charter to become a Municipal Borough. The present London Borough of Enfield came into control of local government from 1 April 1965, made up of Enfield BC, Edmonton BC and Southgate BC.

Agriculture in the Enfield area dates back (and still continues) more than a thousand years, with the first record in the Domesday Survey of 1086. Farming was radically altered by the Enfield Enclosure Act of 1803. This Act abolished the medieval system of open field cultivation, for the enclosed system. Market gardening and nurseries both rapidly increased in Enfield in the last thirty years of the nineteenth century. Market gardening didn't last long after the Second World War, but

there are still nurseries today. Enfield was granted a market by King James I with a charter of 1616 that prospered for 100 years or so, before it declined. It is only since the later part of the nineteenth century that it has prospered again.

Industry in Enfield prior to the nineteenth century consisted of various mills, dating back to at least to 1086. Notably Ponders End Mill that dates from mid seventeenth century still operates, on a site used for this purpose for possibly a thousand years. The earliest factories in Enfield date from the first decade of the nineteenth century. There were stagecoaches and carts to transport people and goods to and from Enfield before 1840. But it was the coming of the railway first to Ponders End, Enfield in 1840 (and later other parts) that made a big difference to the industry. Rail transport for goods went over to road radically from the 1960s and the arrival of the M25 in the 1980s made a difference. Enfield's population illustrates the change in jobs in the area, from 1801 at 5,095, to 10,930 in 1861, to 25,381 in 1891, to 64,497 in 1911 and 104,270 in 1951.

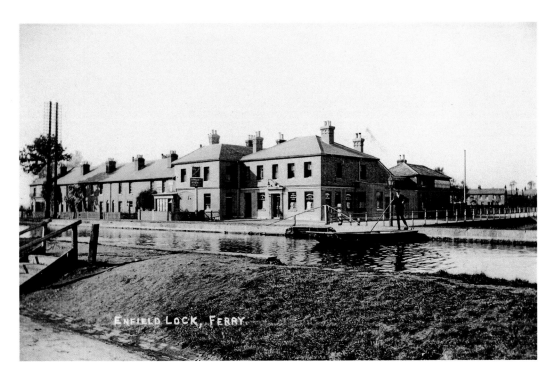

Ordnance Road, Enfield Lock

The corner building is The Greyhound public house, which was first recorded in 1867. The ferry was a short cut off the bridge that is outside the picture to the left. Both bridge and ferry have been replaced by Causeway Bridge (built 1998) and Smeaton Road that can be seen in the top right hand corner of the picture.

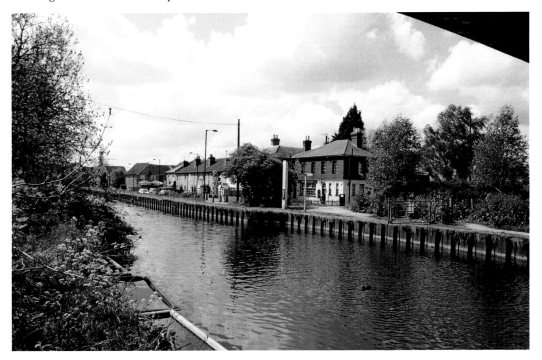

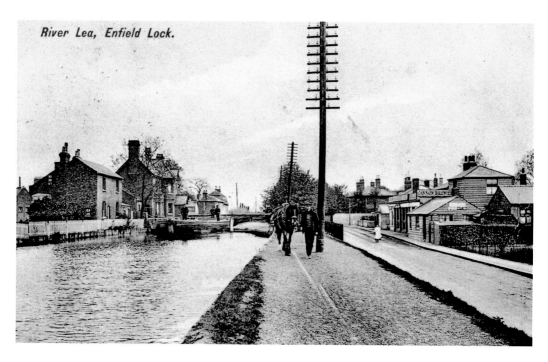

River Lea, Enfield Lock.

Ordnance Road, Enfield Lock

The Lee Navigation dates from 1767, the lock keeper's house in the distance has a plaque noting its construction in 1889. The public house on the right that has been replaced by the housing is the Ordnance Arms, that is first recorded in 1862 and it closed not long after the First World War.

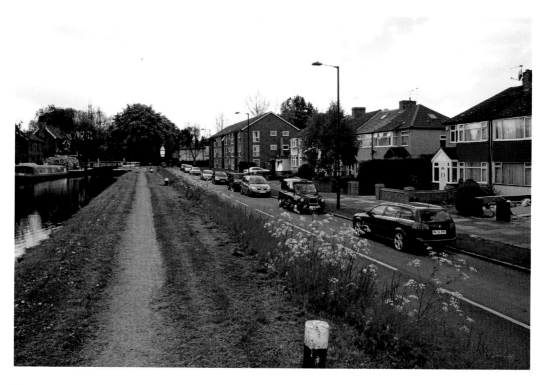

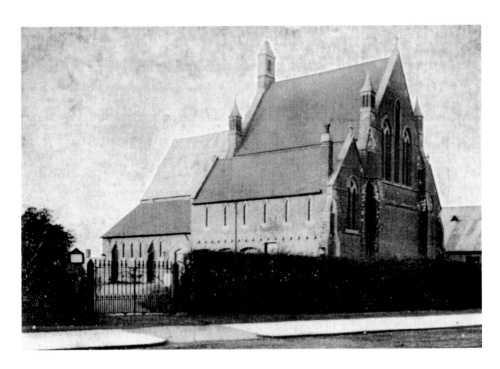

Hertford Road, Freezywater

Here we have the second stage of the St George's Church which was consecrated in September 1900. The third part that completed the building dates from 1905. Most of the first St George's Church is hidden by its replacement, it was first used in 1896 and was replaced in October 2000 by the Church Hall.

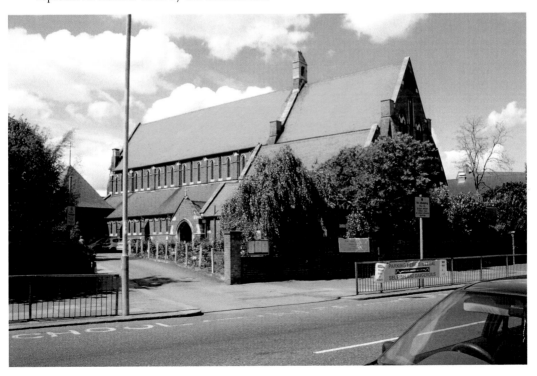

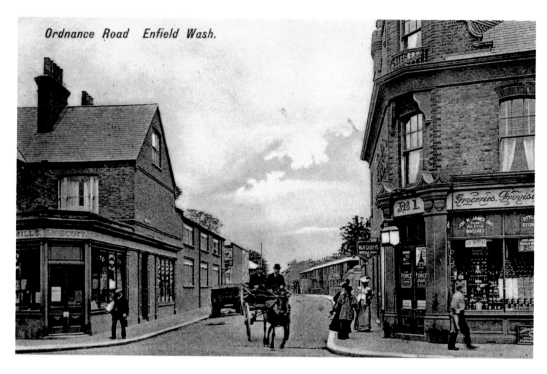

Ordnance Road Enfield Wash.

Hertford Road (end of Ordnance Road), Enfield Wash

Ordnance Road was widened with the building of the library on the north corner in 1964. Linscotts (corn merchants) had the shop on the left 1870–1964 and they occupied the other corner shop until recently, from 1939. Style Bros sold groceries and provisions in the south corner shop 1900–1909.

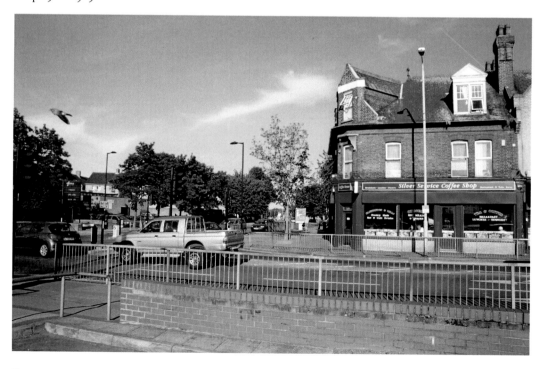

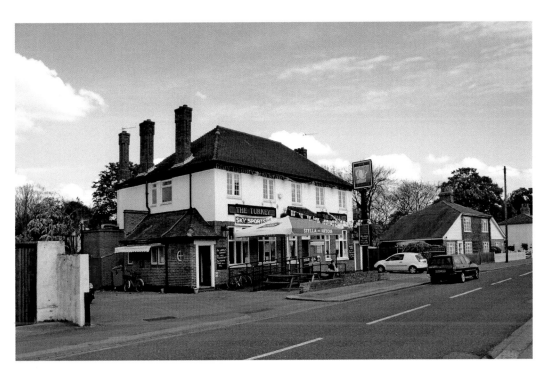

Turkey Street, Enfield Wash

The first record of the Turkey public house being used for the sale of beer is in the Charringtons Lease Book of 1868. The present day building that replaced the previous dates from 1936, with extensions in 1937 and 1984.

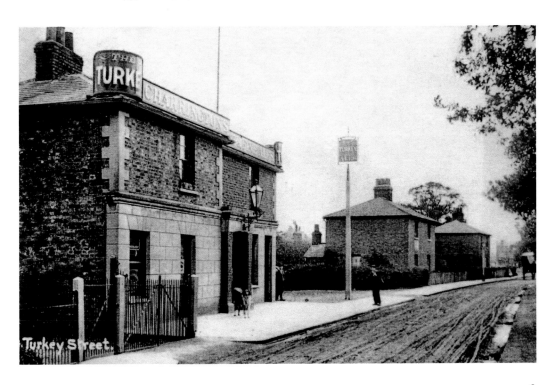

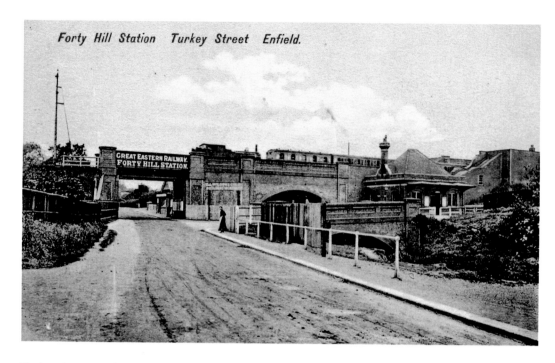

Forty Hill Station Turkey Street Enfield.

Turkey Street, Enfield Wash

This station in its first and second periods of passenger use was called Forty Hill station, 1 October 1891–1 October 1909 and 1 March 1915–1 July 1919. It became the present name on the reopening of the line to passengers on 21 November 1960. The station was altered in the summer of 1967 and the ticket office was rebuilt in March 1988.

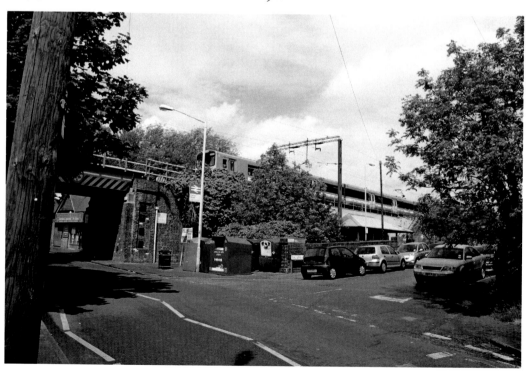

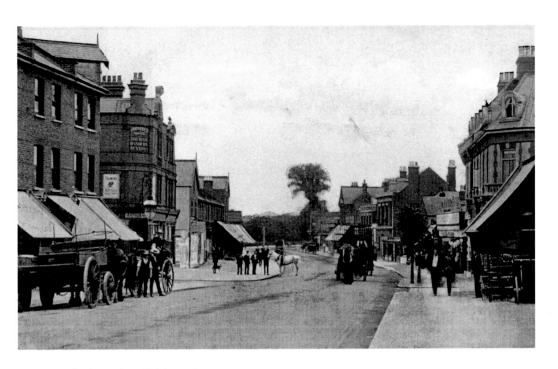

Hertford Road, Enfield Wash

These two pictures are a little over a hundred years apart, but the only major change is in the distance. The tall tree has been replaced by a tower block, Herm House, Eastfield Road, which dates from 1969. The Barclay's Bank building was built in 1899, but it was an off-licence for a long time. The HSBC (ex Midland) Bank building dates from 1903.

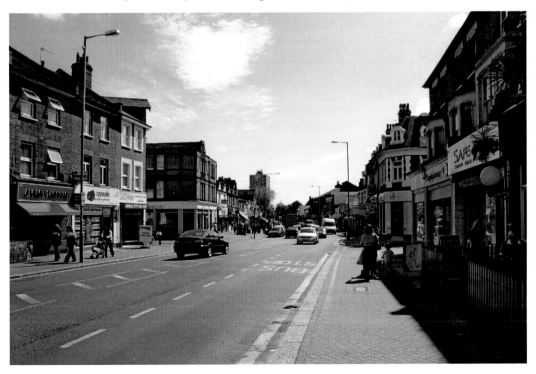

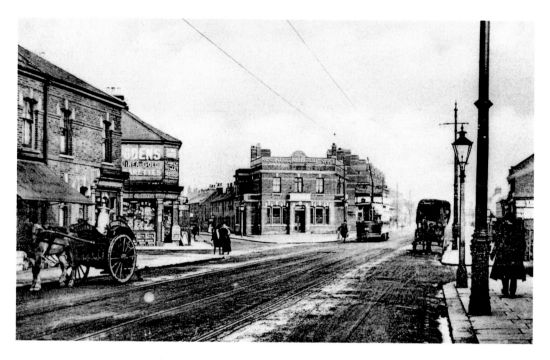

Hertford Road, Enfield Highway

The road going off to the right is the only landmark common to the two pictures, this is Oatlands Road. The building next to the tram is the Roebuck public house, in use 1855 (Kelly's Directory) to 1972. The road going down the left of the pub is Old Road and the nearer one is St James Road.

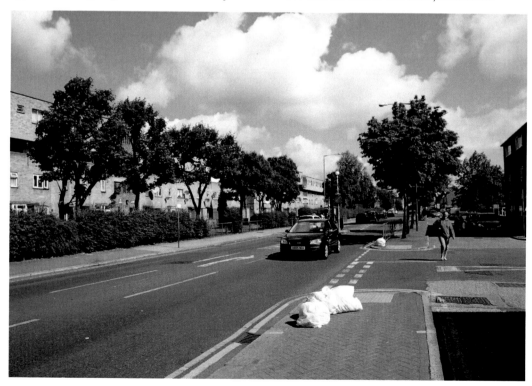

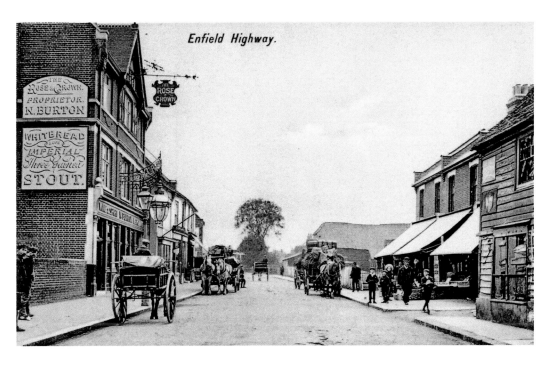

Enfield Highway.

Hertford Road, Enfield Highway
The right hand side of the road has completely changed between these two pictures, the first change was the library opening in 1909. The Rose & Crown public house is first recorded in 1752, the present building dates from 1895. It was extended in 1929 and changed trades recently.

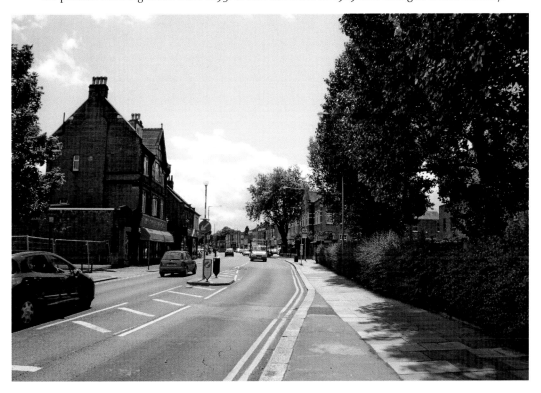

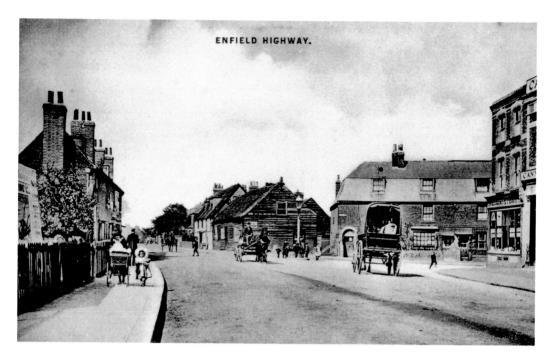

Hertford Road (Green Street junction), Enfield Highway

The only landmark is the shop on the corner of Hertford Road and Green Street, this became part of the public house in 1937. There has been a public house on this site since 1722, most of this period traded as the Kings Arms. The other corner of Green Street was rebuilt in the late 1930s.

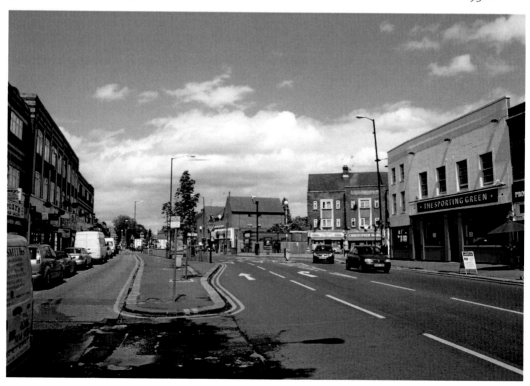

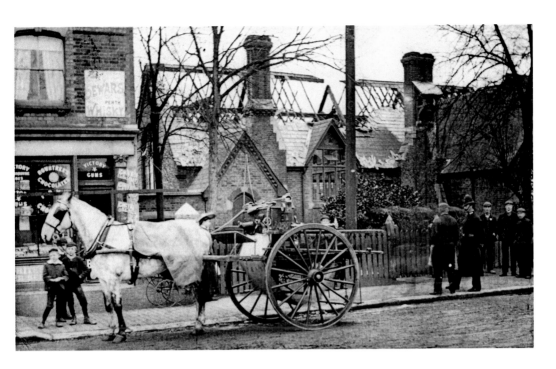

Hertford Road, Enfield Highway

Just out of shot to the right is St James Church. Illustrated here is St James's Church of England Primary School that was built in 1872. Here we have the school soon after a fire on the 4 December 1906. The school was rebuilt, and resumed use, before moving to Frederick Crescent in 1969. The Enfield Highway Community Centre replaced the school. It has a foundation stone dated 16 April 1980.

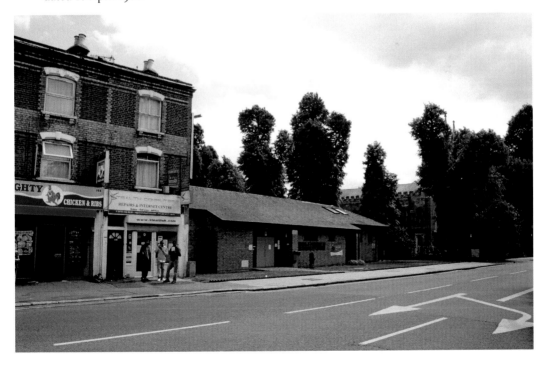

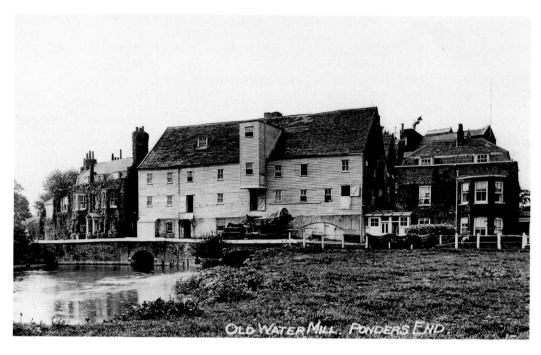

Wharf Road, Ponders End

The oldest part of the flour mill dates from the mid seventeenth century. The Wright family have had the mill since 1863. The mill was extended in 1880 and 1961. The only angle for the current picture is from the Lea Valley Road flyover. The original picture is from the opposite side of the mill.

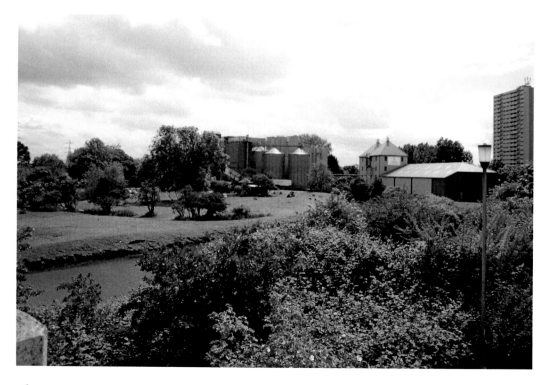

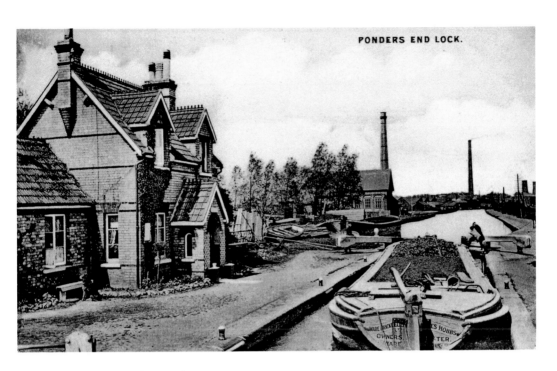

Wharf Road, Ponders End

The Lee Navigation dates from 1767, the lock keeper's house is late Victorian and the present lock dates from 1959. The nearest chimney and building was the local pumping station, and since 1995 it has been the Navigation Inn. Since 1963 the building has been the other side of the Lea Valley Road flyover.

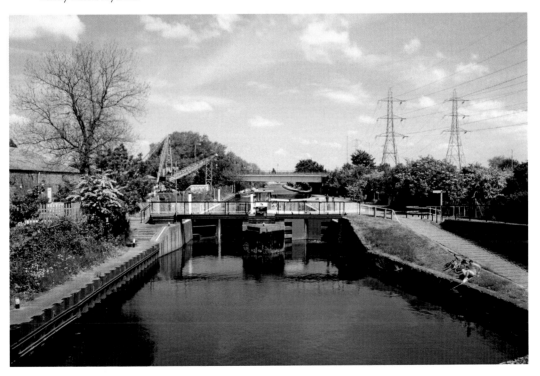

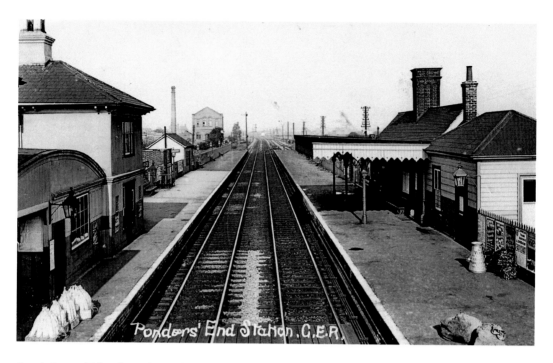

South Street/Wharf Road, Ponders End

This station opened on the same day as the railway line between Stratford and Broxbourne, on the 15 September 1840. This is the first railway line in Enfield. The railway station was completely rebuilt in February 1970 and the housing was built at about the same time.

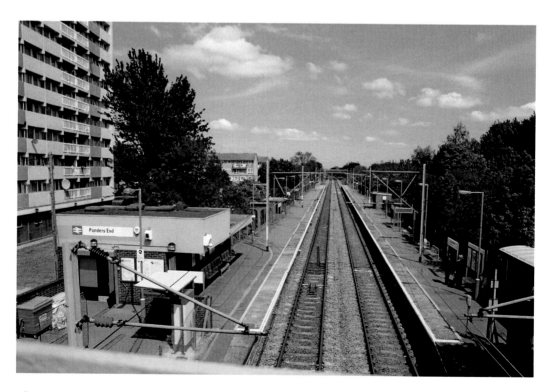

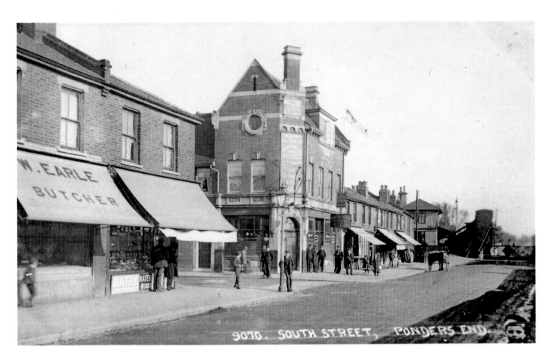

South Street (and Station), Ponders End

The first record of an Anglers Retreat public house on the corner of Alma (Crimean War Battle 1854) Road is in 1871, the building illustrated was there from 1897 to 1968. The distant level crossing was last used in 1969, having fallen out of use since 1963 when the Lea Valley Road flyover was built.

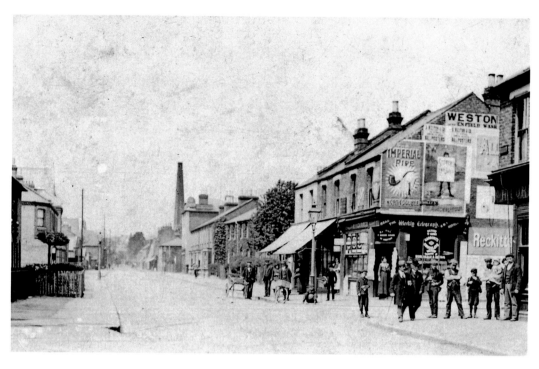

South Street (looking West), Ponders End
The only landmark in this picture is the chimney, which was part of the United Flexible Tubing Co. (trading 1898 to 1991) factory on the corner of Scotland Green Road. The road going off to the right behind the posing people is Stanley Street, which disappeared with all the rest of the buildings about forty years ago.

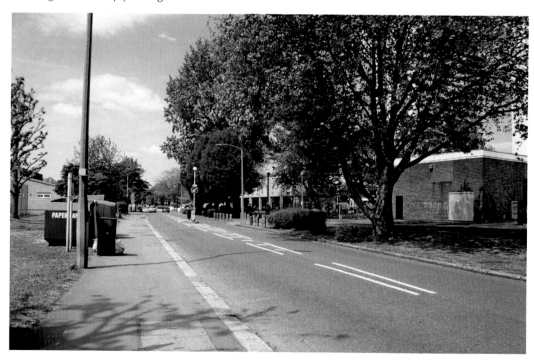

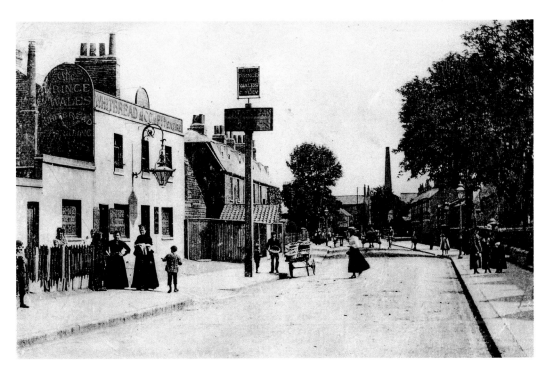

South Street (looking East), Ponders End

The Prince of Wales public house is first noted in the Trading Records of Whitbread of 1845. In January 1911 the public house became the Ponders End Liberal and Labour Club, later becoming the Ponders End Working Mens' Club. The chimney in the distance is part of the factory of United Flexible Tubing Co.

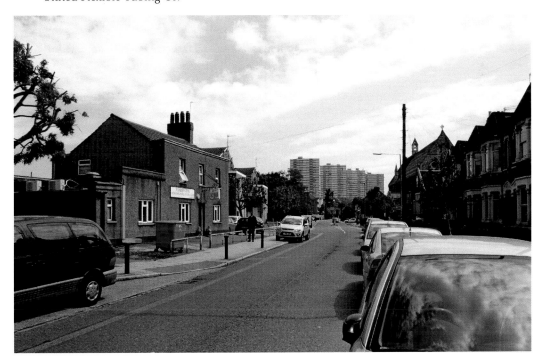

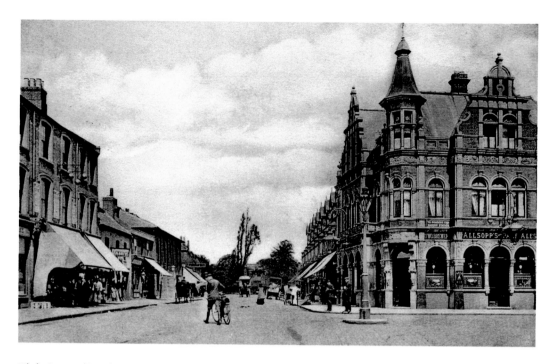

High Street (South Street Junction), Ponders End

The only part of the old buildings in the new picture are those beyond the Two Brewers public house. There had been a Two Brewers on the corner of High and South Street since at least 1716. This, the last building on the site opened in March 1896. The public house and the buildings on the left were all very badly damaged in the bombing on the 30 September 1940, and were later demolished.

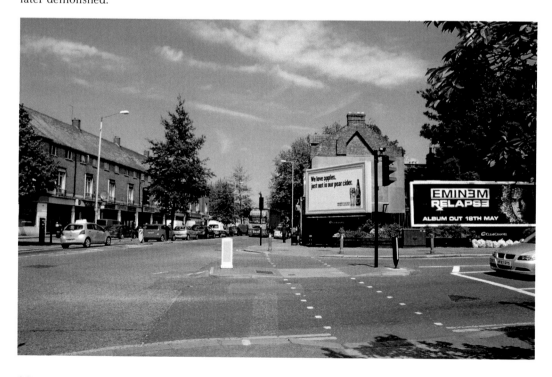

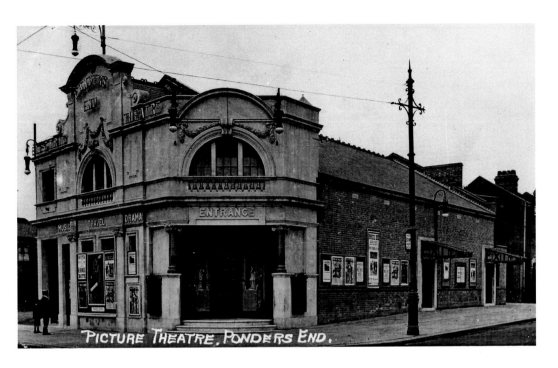

PICTURE THEATRE, PONDERS END.

High Street/Lincoln Road, Ponders End

The Ponders End Electric Theatre was opened as a cinema in January 1913 and ceased to be one on 3 September 1939. The building was damaged in the bombing of the 30 September 1940 and was empty until the mid 1950s, when it was purchased by the council. Howard Hall was used for many years but then was empty for a long time before opening as a pub called the Picture Palace on 6 June 2001.

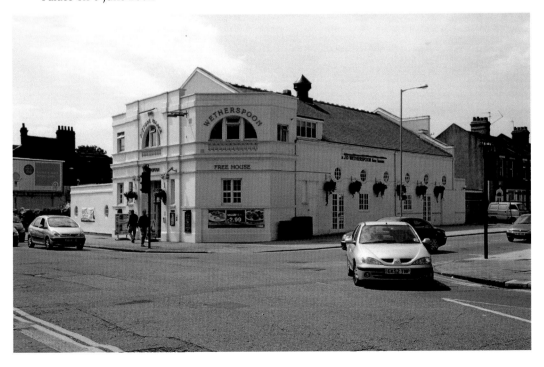

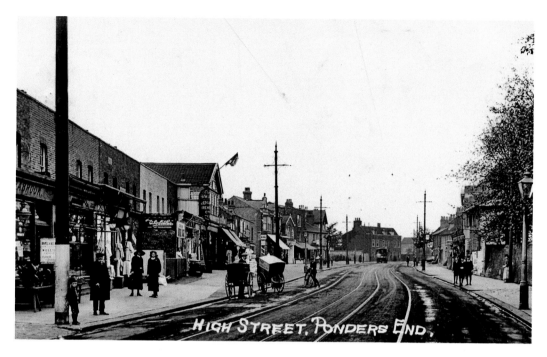

High Street, Ponders End

High Street, Ponders End

The distant part of these two pictures is fairly unchanged. The 1960s building on the left is Ponders End Police Station; this site was acquired in 1962 and the building was completed in 1969. The building with the flag near its top is the Swan (first recorded in 1851) public house that used to occupy the empty site to the right of the police station.

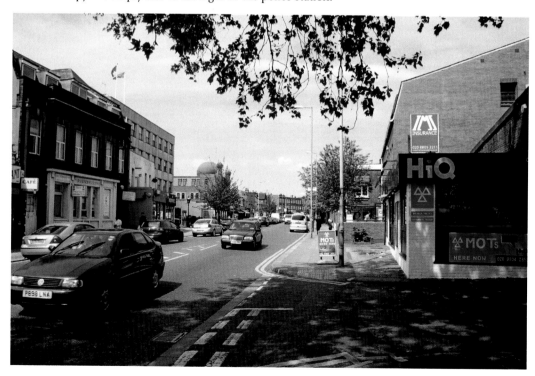

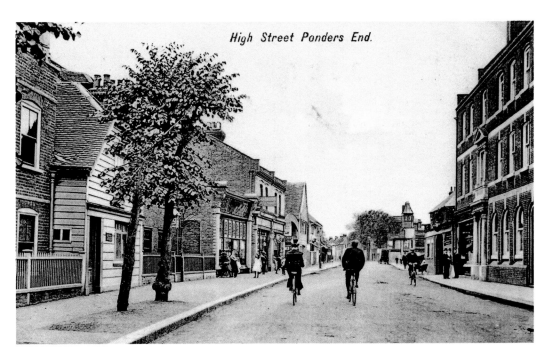

High Street Ponders End.

High Street, Ponders End
Barclays Bank used to occupy the three-storey building next door to the present one, from the early 1890s. The near left shops were rebuilt in the late 1930s. The postcard picture dates from a time before the electric tram that first ran here (as previous) between 11 December 1907 and 12 October 1938, when they were replaced with trolleybuses.

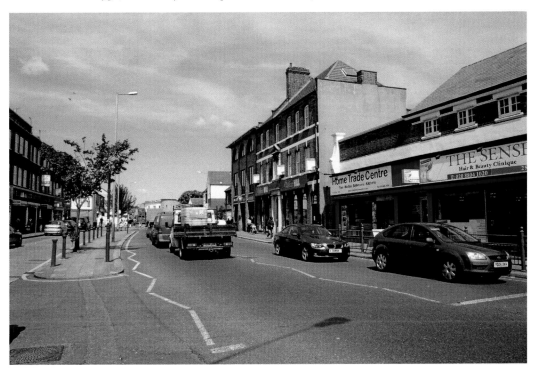

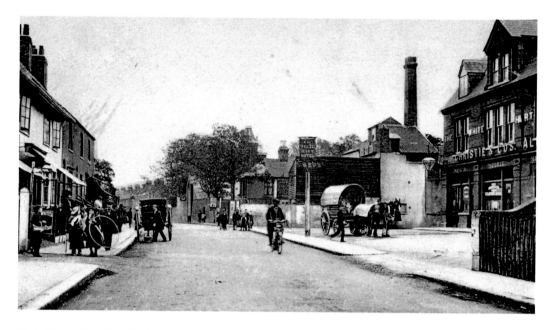

High Street, Ponders End

The only common feature of these two pictures is the White Hart public house. This is probably the oldest inn in Ponder End; its earliest record is a taxation demand of 1627. The chimney and buildings to the left of the public house is the Ponders End Brewery which closed early in the twentieth century.

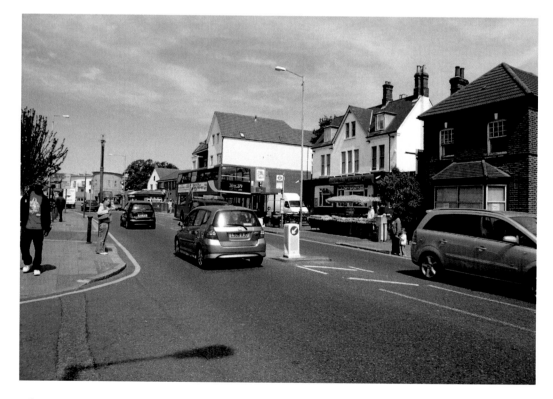

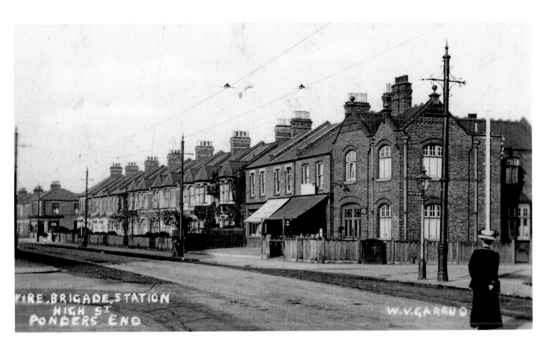

High Street/Nags Head Road, Ponders End

The far shop is the only part of the buildings on the corner of High Street and Nags Head Road to appear in both of these pictures, the terrace of houses beyond was built in 1889. The building right on the corner was Ponders End Fire Station 1891 to 1966, it was then for a while an Ambulance Station. This set of buildings was demolished in 1987 and is now Vincent House.

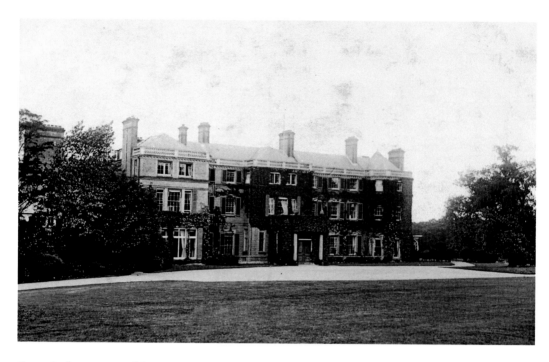

Trent Park House, Cockfosters
The first picture of Trent Park House is as it was from 1895. The second picture is as has been since the house was greatly altered between 1926 and 1931. The house was used during the Second World War for the interrogation of German Officers. Since 1951 it was used by Trent Park College, it changed name in 1978 to Middlesex Polytechnic and Middlesex University in 1992.

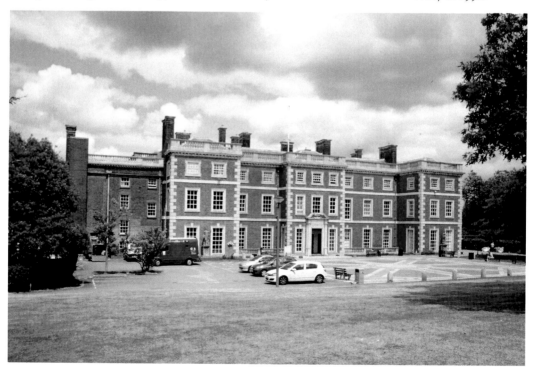

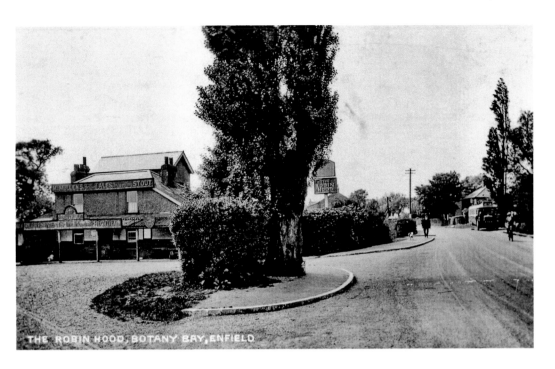

The Ridgeway, Botany Bay

The first record of the Robin Hood public house was in the Post Office Directory of 1845. The original building was on the Potters Bar side of the current building. The current public house was built soon after the brewers McMullens purchased the pub in 1935.

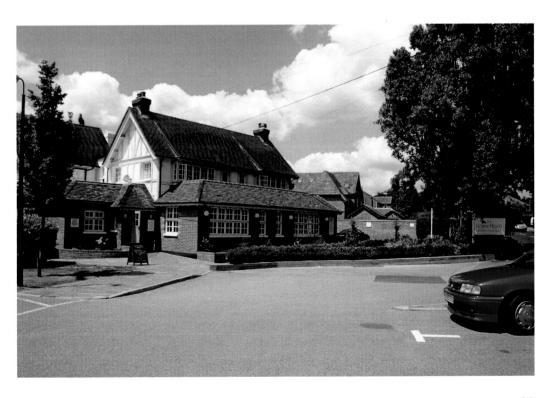

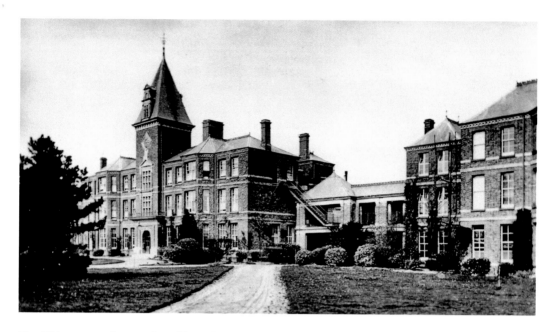

The Ridgeway and Lavender Hill, Enfield
Chase Farm School was erected by the Edmonton Boards of Guardians as a Poor Law orphanage in 1886. The building's present use as a hospital started in September 1939.

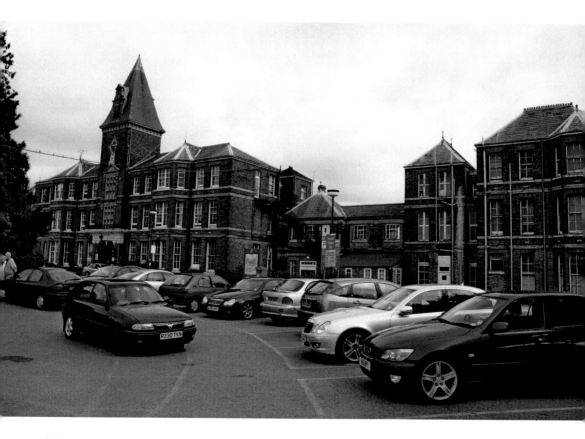

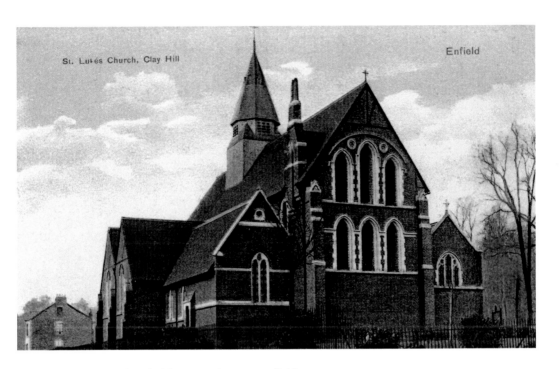

St. Luke's Church. Clay Hill

Browning Road and Phipps Hatch Lane, Enfield

St Luke's Church is on the corner of Browning Road and Phipps Hatch Lane. The old picture shows the church as it was when the first stage was completed in 1899 and consecrated in 1900. The final stage of the church, to the right of the bell tower, was built in 1906. This was one of the cases impossible to take from the original position.

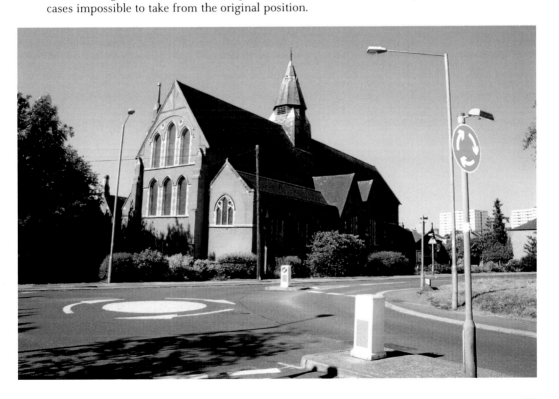

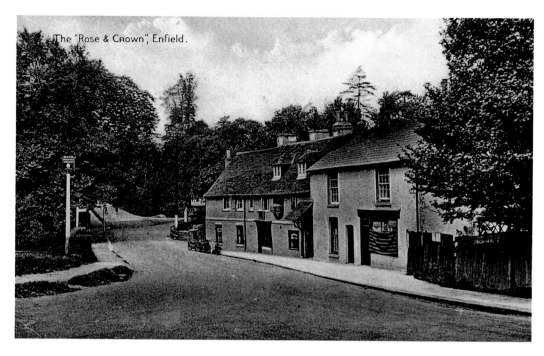

The "Rose & Crown", Enfield.

Clay Hill, Enfield

The Rose & Crown, Clay Hill, is first recorded as a public house in 1716. To the left is Hilly Fields, first opened to the public in 1911 and behind the pub is Whitewebbs that opened to the public in March 1932. The shop on the right from the early 1950s until it closed in 1965 sold sweets and confectionery; before that it had been an off-licence.

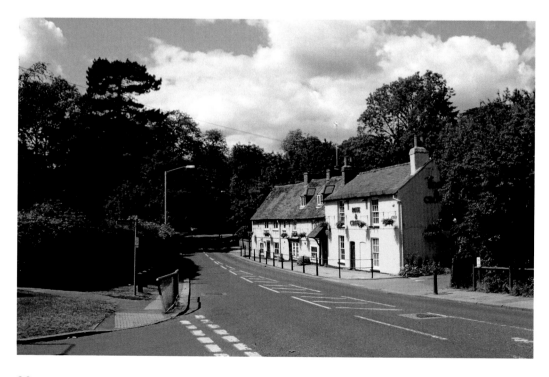

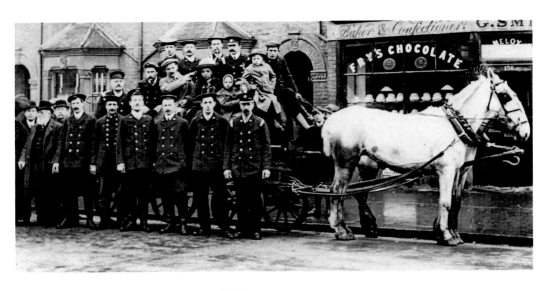

Lancaster Road (Lynn Street), Enfield

George Smith had this bakery and confectionery shop from 1895 and the house next door from 1913. The family sold the shop during the Second World War and vacated the house in 1957. The men in uniform are from the Enfield Volunteer Fire Brigade who started in March 1880. The Brigade changed over to the professional body of today in stages from December 1930.

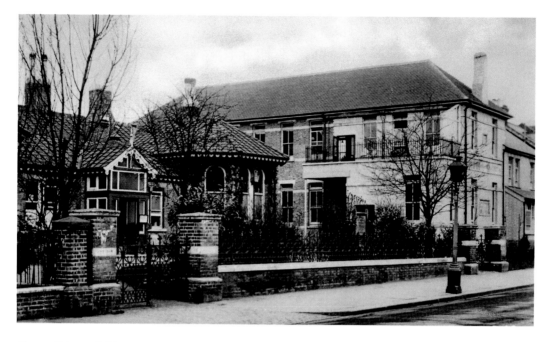

Chase Side, Enfield

The single-storey building is the Cottage Hospital, its foundation stone was laid 28 November 1874, it was officially opened 8 August 1875 and the first patient admitted 5 October 1875. It was extended in 1888, 1892, 1897, 1898, and 1906. On the right is the War Memorial Hospital, work on it started in December 1922, and it opened in autumn 1924. Both were closed, demolished and the site rebuilt on in 1984.

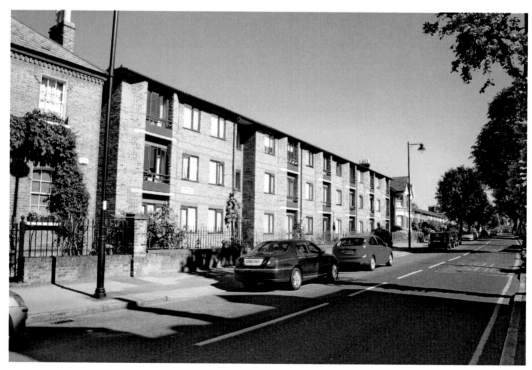

SIR WALTER RALEIGH'S HOUSE.

(Formerly standing at Chase Side, Enfield).

The " Tudor " Series No. 6.

Chase Side Crescent, Enfield

This house was on the corner of Chase Side Crescent and Gordon Road. There is no proof Sir Walter Raleigh (*c.* 1552 to 29 October 1618) lived here. This sixteenth-century house was sold and demolished in 1886. In 1887 the present three shops and flats were built and called Raleigh Buildings.

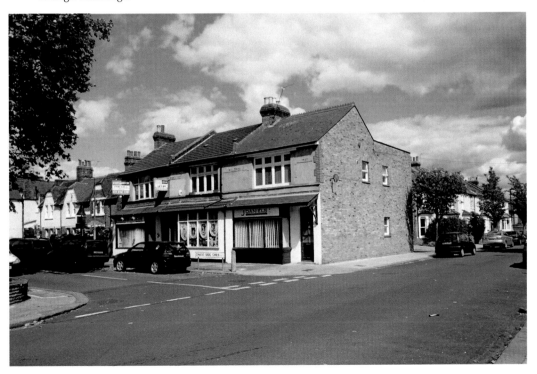

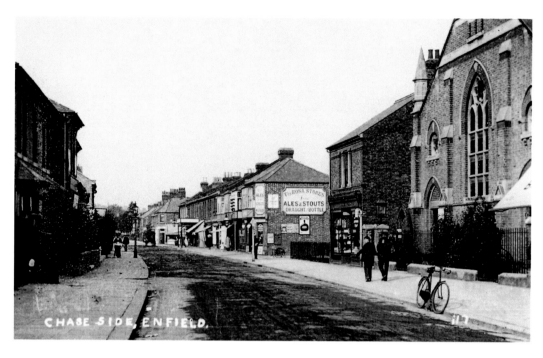

Chase Side, Enfield

The church on the right was used by the Primitive Methodists from 1894 to 1936, from when the Salvation Army used it for a time. The road going off to the right is Halifax Road, that was laid out on part of the Gordon House (demolished 1858) Estate, in the 1870s.

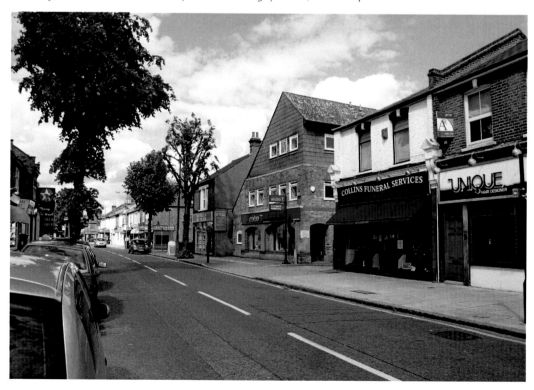

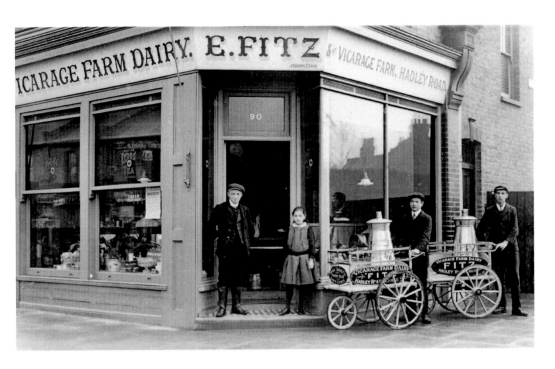

Chase Side (Holtwhites Hill), Enfield
The Fitz family had this dairy on the corner of Chase Side and Holtwhites Hill from 1908 the year the building was completed, to sometime during the Second World War. Enzo's Restaurant that occupies the property now has been there since 1988.

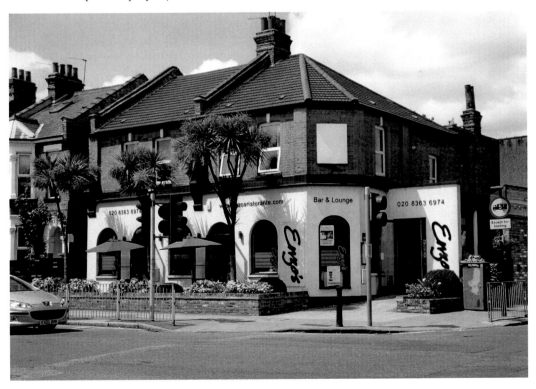

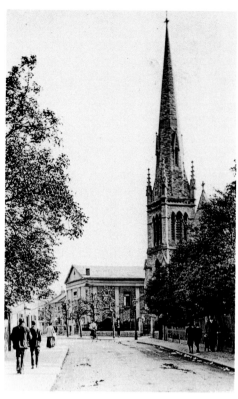

Chase Side, Enfield
The foundation stone of Christ Church, Chase Side, was laid 29 June 1874 and it was dedicated on 18 November 1875. The Lecture Hall on the far side of the church was in use 1792–1963. The foundation stone of the Church Hall on the near side of the church was laid on 15 July 1939.

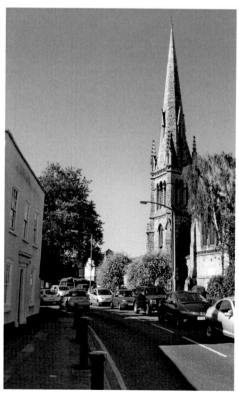

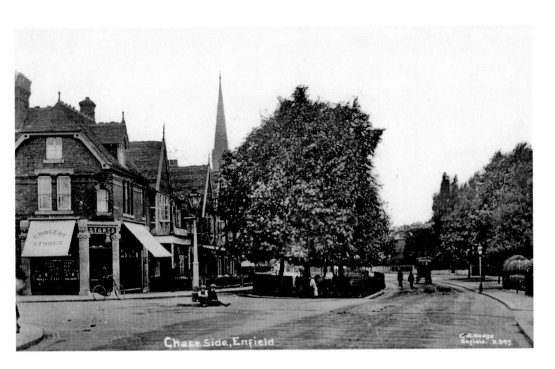

Chase Side (Chase Green Avenue), Enfield

Here we have Chase Side with Chase Green Avenue, dating from the 1880s, going off to the left. The spire belongs to Christ Church that was built in 1875. The only changes are the gas lamp in the middle of the junction and the corner shop which is now an office.

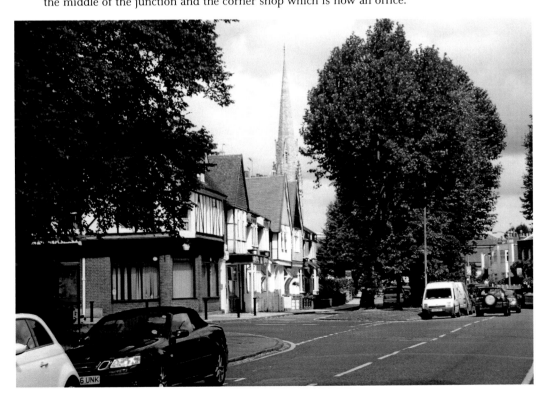

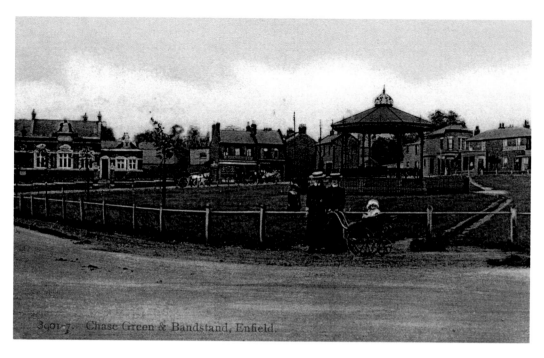

3901-7. Chase Green & Bandstand, Enfield.

Chase Side, Enfield

The Bandstand was erected August 1900 on Chase Green; here we see it from Chase Side, with Windmill Hill in the background. The War Memorial that is on the site of the Bandstand, was first used on Remembrance Sunday November 1921. Chase Green had come to the Parish by the 1803 Inclosure Act.

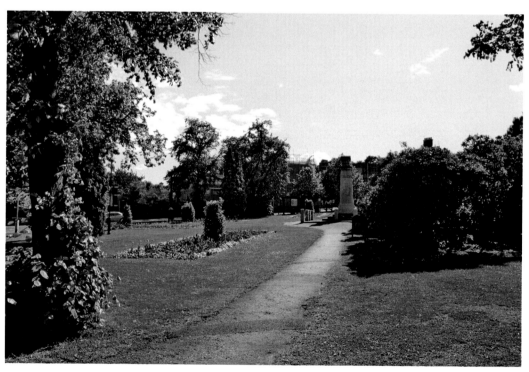

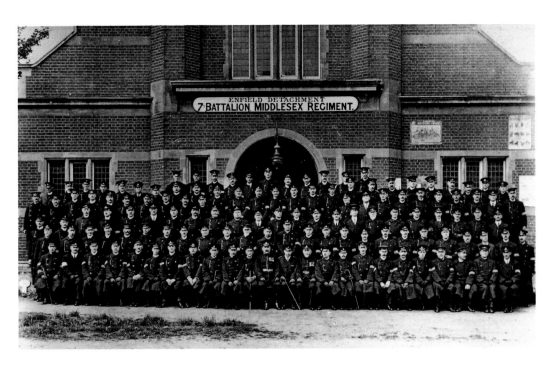

Old Park Avenue, Enfield

The Drill Hall was built in 1901 for the recently formed Enfield Town Company of the 1st Volunteer Battalion of the Middlesex Regiment. The earlier picture was taken during the local Police Specials stand down after the First World War, *c.* 1919. Old Park Avenue was laid along the line of the drive to the house Old Park *c.* 1913.

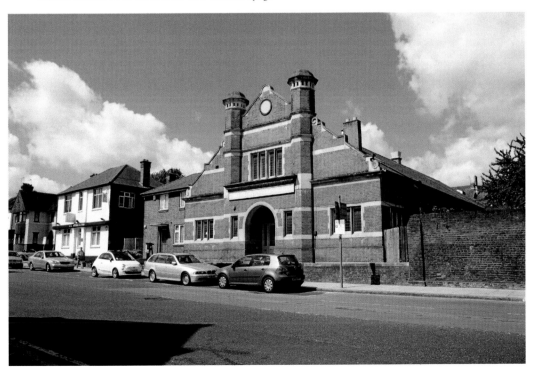

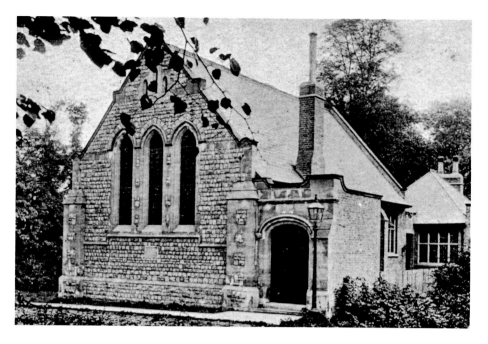

Old Park Avenue, Enfield

The foundation stone of the St Paul's Presbyterian Church Small Hall was laid on the 21 December 1901 and came into use the following year. The major part of the church on the corner of Church Street and Old Park Avenue was started in 1906 and first used on 26 September 1907.

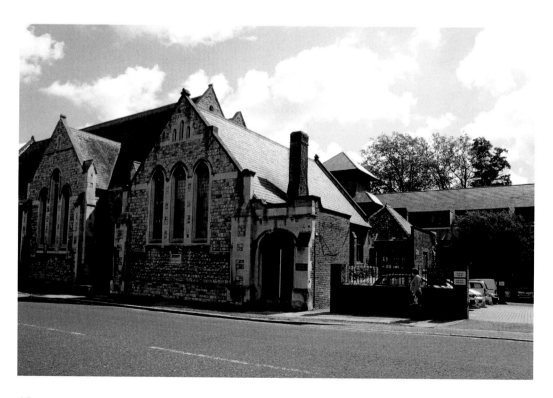

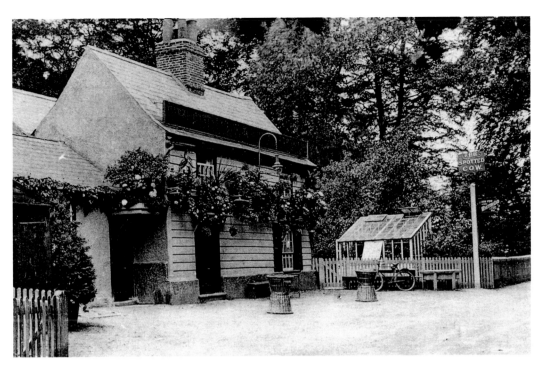

Bulls Cross, Enfield

The Spotted Cow public house is first recorded in 1838 in the Robson's directory. It ceased selling beers in April 1923 and ever since has been used as a private dwelling. Bulls Cross was part of the Roman Ermine Street that went from London to York.

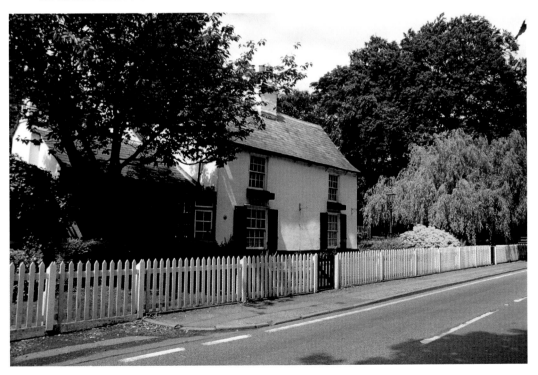

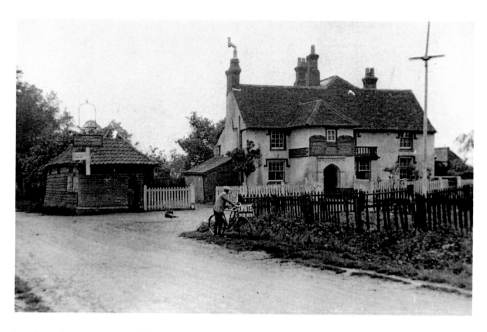

Whitewebbs Lane, Enfield
The King and Tinker public house first appears in the Licensed Victuallers' Records in 1716, but as the Bull. The name of King and Tinker didn't come into use until about 1814.

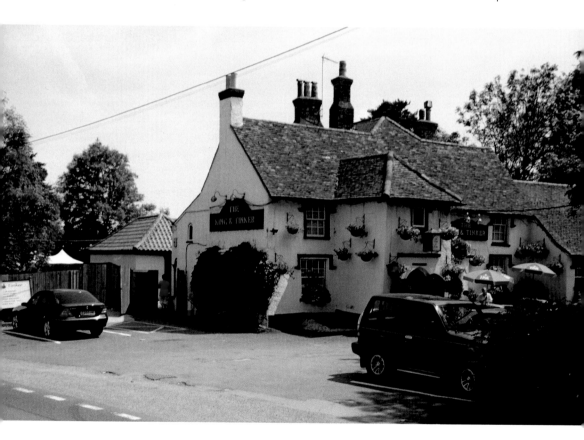

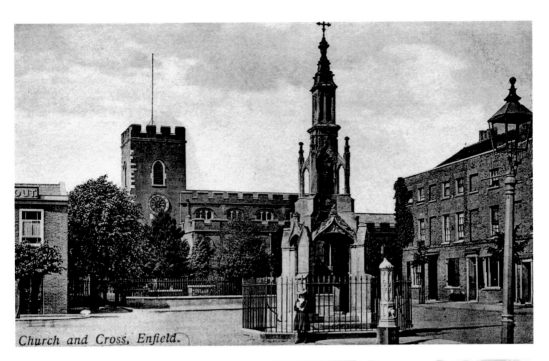

Church and Cross, Enfield.

Bulls Cross, Enfield
The Market Cross was in the Market Place, Enfield Town from 1826. It was purchased by Gussie Bowles, who lived at Myddleton House (built 1818) to be a garden feature, in 1904. At this date the top third of the cross was re-united with the major part. The top third had been taken down a short time before the move, for safety reasons.

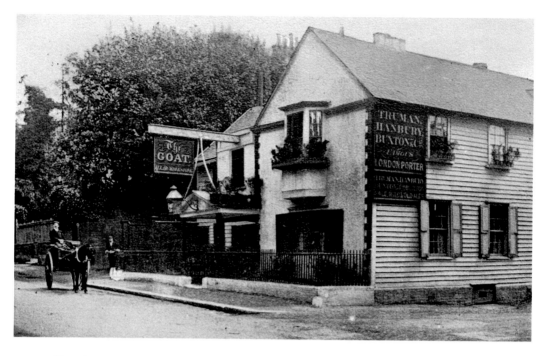

Forty Hill, Enfield

The Goat public house, Forty Hill, on the corner of Goat Lane. The first mention of this seventeenth century building being a pub was in a deed of sale dated 24 January 1721. The trade and name moved down Forty Hill in 1929 and since then this building has been a private dwelling.

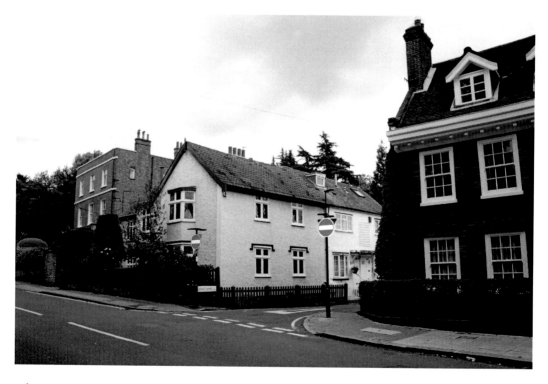

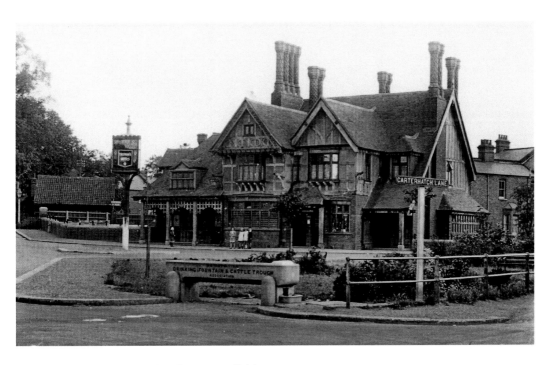

Forty Hill and Carterhatch Lane, Enfield

The Goat public house has been at the junction of Forty Hill and Carterhatch Lane since 1929. It previously was on the corner of Forty Hill and Goat Lane. The building ceased being a public house January 2005, it was empty for a long time before being converted into residential use, like its predecessor. The horse trough is dated 1879.

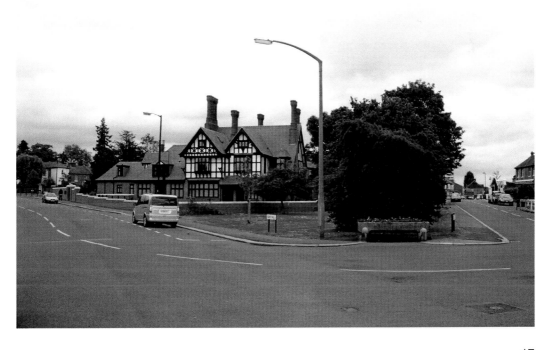

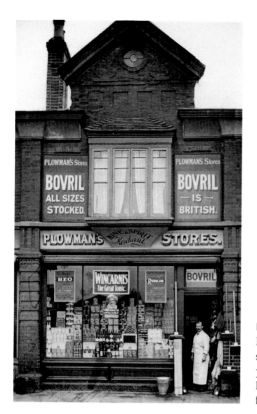

Baker Street (Lancaster Road) Enfield
Robert Plowman (general stores and wine &
spirits merchant) had this shop (built 1894) at
315 Baker Street (opposite the end of Lancaster
Road) at least 1921 to 1927 (there are no records
for 1918-20).

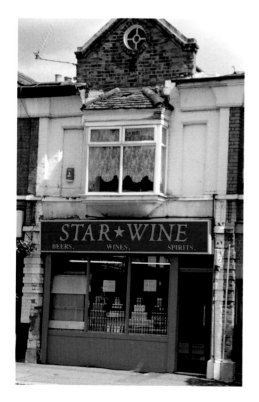

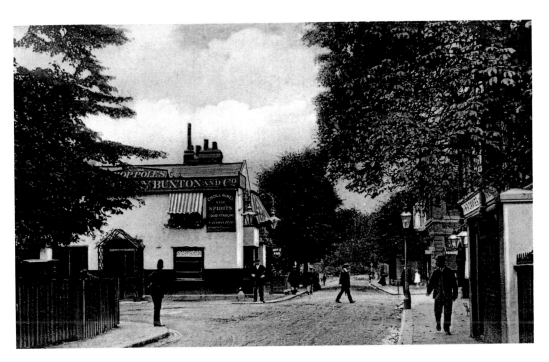

Baker Street and Lancaster Road (Junction) Enfield

The Hop Poles on the corner of Lancaster Road and Baker Street is first noted in the Robson's Directory of 1838. The replacement public house building was opened on the site of the old building on the 12 October 1909.

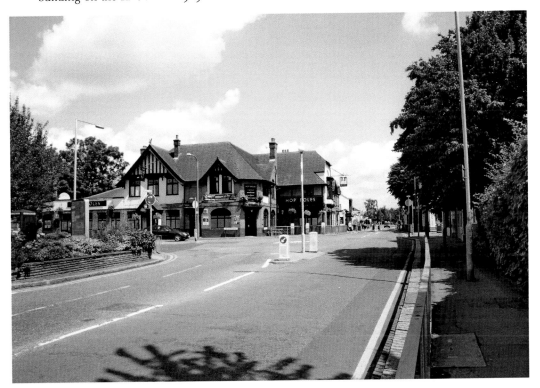

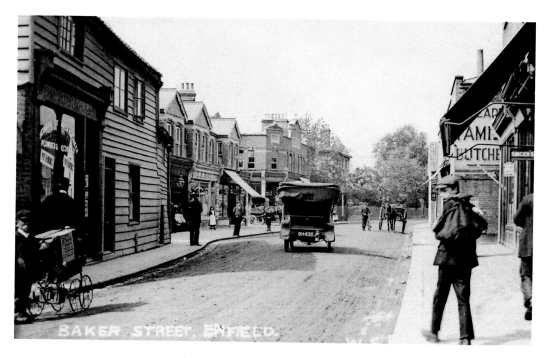

Baker Street, Enfield

The weather-boarded building on the left is the one major change that was demolished *c.* 1960. The next group of shops on the left date from 1904. The building beyond Bell Road is four years older than the previous one, used by Enfield Co-op for many years.

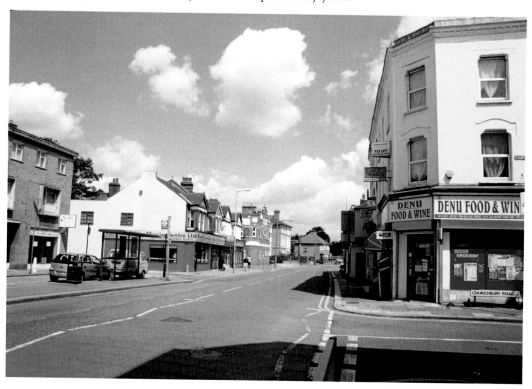

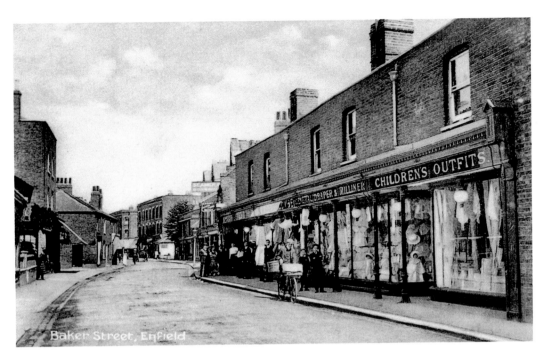

Baker Street, Enfield

Landmarks are the near three-storey building on the corner of Gordon Road and the distant ones on the corner of Churchbury Road. A. C. Tincombes had the draper's shop 1894–1936, it was demolished with the road widening and straightening of 1973–4.

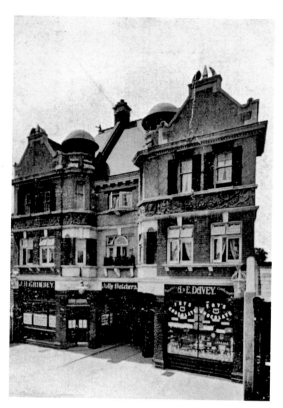

Baker Street, Enfield

The Jolly Butchers public house, Baker Street, is first recorded in 1841. This replacement building was built in 1907. The shop on the right was converted into a restaurant run which was by the brewers in 1972. The three ground floor parts were combined into one between March and August 1988.

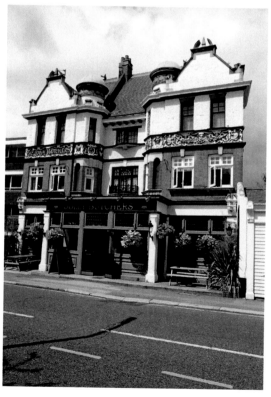

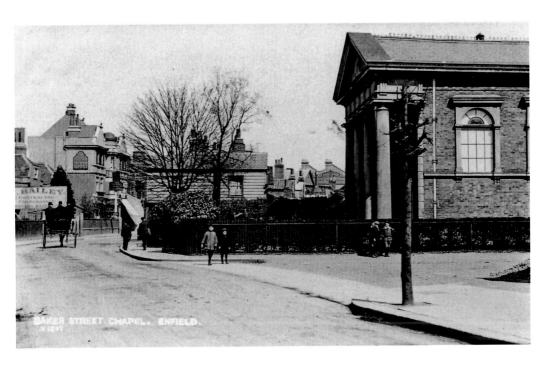

Baker Street, Enfield

The pillared building is the Non-Conformist Chapel that was first used on the 11 December 1862, built on a nonconformist worship site used since the mid seventeenth century. The road at this point was widened and straightened in 1973–4 by demolishing the buildings on the right side of the road.

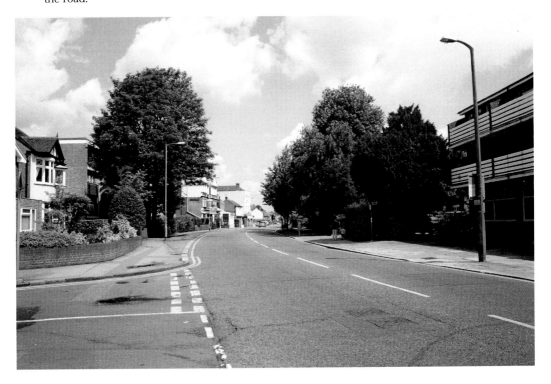

Church Lane from Church Walk, Enfield

Church Walk dates back to at least 1590 and Church Lane to 1803. The building on the left dates from the early nineteenth century. It housed Enfield's fire engine, was used as a mortuary from 1882 and since the early 1930s has been used for office purposes. The dwellings were demolished between 1959 and 1967.

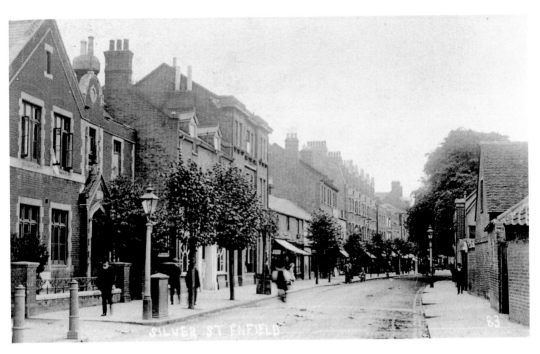

Silver Street, Enfield

Silver Street looking south at the point where Churchbury Lane (left) and Church Lane (right) go off of it. The one property change is the single-storey building part way along the left-hand side of the street. The first building on the left was built in 1876 for the Enfield Church School of Industry.

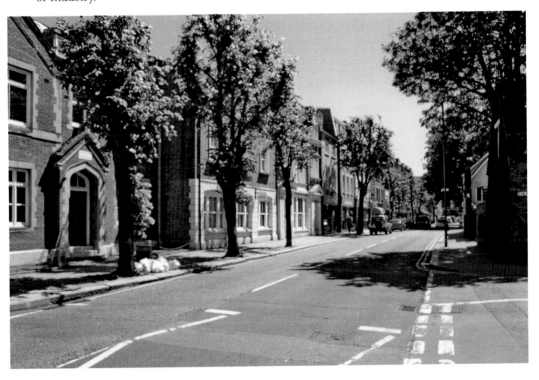

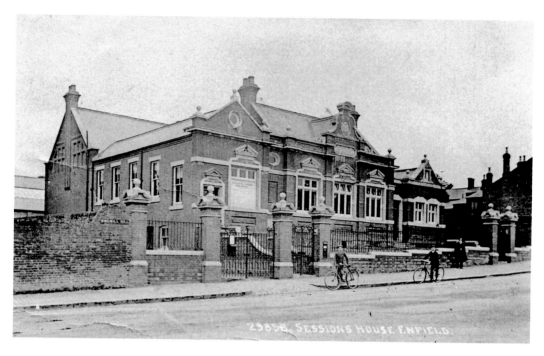

Windmill Hill (Old Park Avenue), Enfield
The Court House, Windmill Hill was first used in September 1900. The brick wall and railings have been altered and cut back so that the Court House is now on the corner of Old Park Avenue since *c.* 1913.

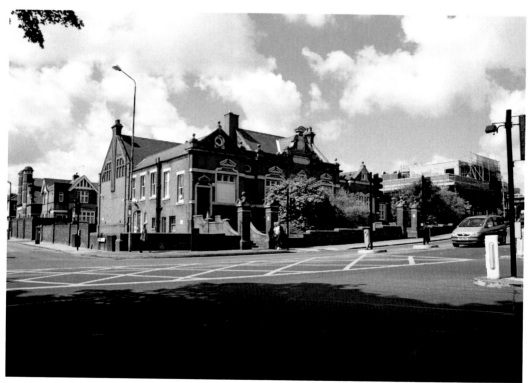

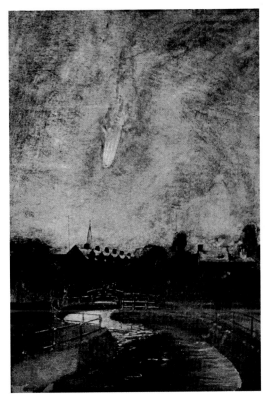

River View, Enfield

This is a artists' impression of the first
Zeppelin shot down, over Cuffley by Flight-
Lieutenant William Leefe Robinson VC,
it is recorded as having been seen falling
throught the air in flames by people in
Enfield. The one thing wrong is the spire
of Christ Church, Chase Side, is in fact out
of sight to the right by quite some distance.

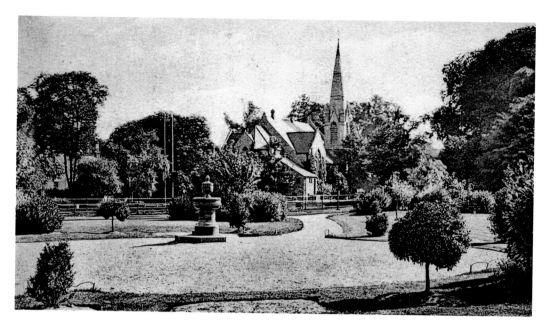

Chase Side and Church Street, Enfield
The gardens were laid out to mark Queen Victoria's Jubilee of 1897, but they were not completed till 1900. The drinking fountain was replaced by the Millennium Sundial unveiled on 8 September 2000. Beyond the New River is Wesleyan Methodist Church that was started in August 1889, its memorial stones were laid in October 1889 and first worship took place in May 1890.

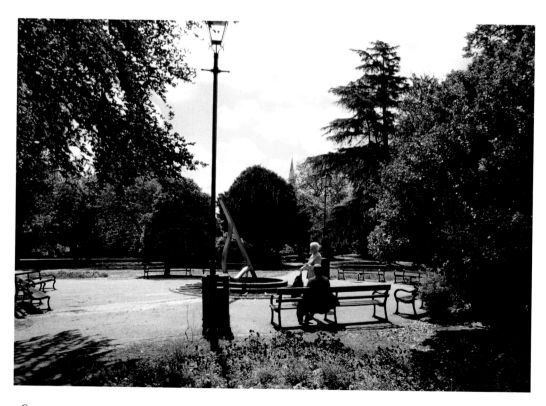

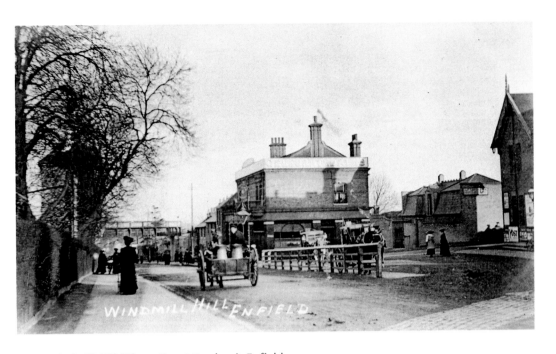

Windmill Hill (Chase Court Gardens), Enfield

Down the hill is the railway bridge that came into service 4 April 1910. The building on the right edge of the old picture is the terminus predecessor to the present Enfield Chase station, first used 1 April 1871. The building in the centre of the postcard is the Windmill Inn that started trading about the same time as the terminus. Both these buildings were demolished *c.* 1982, for the present buildings.

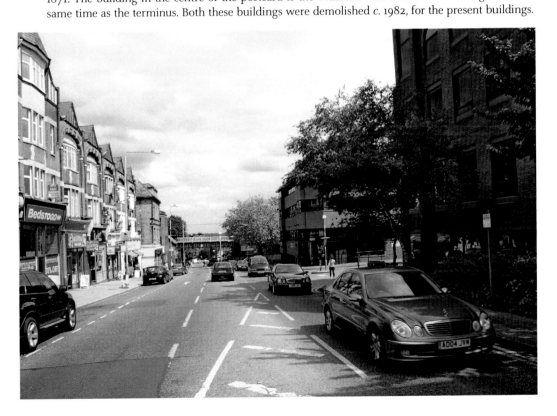

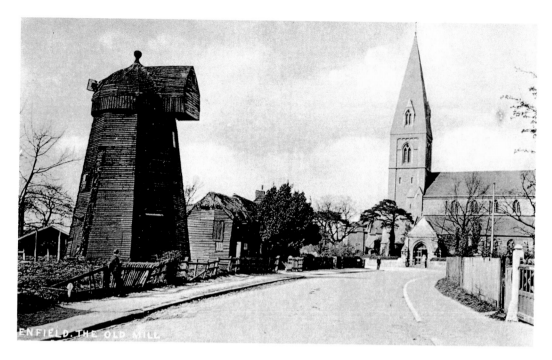

Old Park Road, Enfield

There have been windmills on this site since the sixteenth century, this one was built in the early nineteenth century. It last worked in 1887, the sails were removed in 1901 and the mill was demolished in September 1904. St Mary Magdalene's Church, Windmill Hill, was built in 1883. It was built at a cost of £32,000 in memory of Philip Twells MP by his widow Georgina Twells.

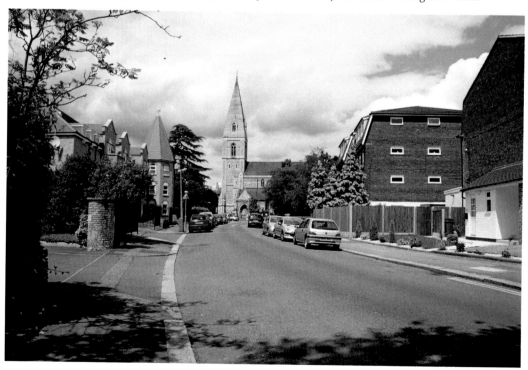

Bury Street West, Bush Hill Park

The first record of the Stag & Hounds public house is in the Licensed Victuallers' Records of 1759. In 1925 the current Stag & Hounds was built and the previous one was demolished. The previous building stood roughly where today there is a car park on the right side of the current public house.

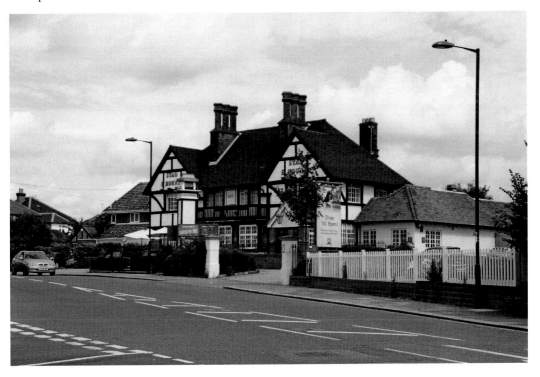

Little Bury Street, Bush Hill Park

The old and new bridges cross Salmons Brook. The eighteenth-century terrace of houses was demolished in the 1930s and was called Montefiore Place. The original Beehive public house was in Bury Street nearly opposite the Stag & Hounds and was first recorded in 1855. The present Beehive can be seen in the distance where it started trading in 1936.

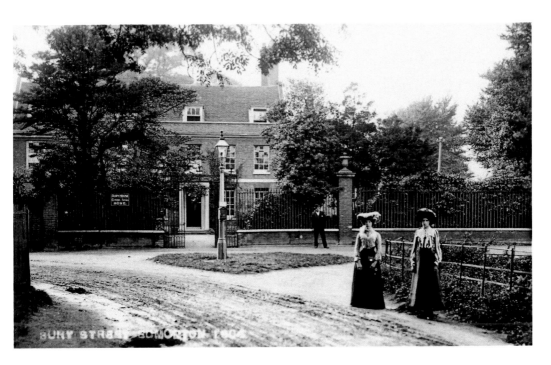

Bury Street West, Bush Hill Park

The Nurses' Institute used Bury House, Bury Street from 1900, to the late 1920s. The shops etc. of Cambridge Terrace, Bury Street West (name change as per the building of the Great Cambridge Road) were built soon after the demolition of Bury House.

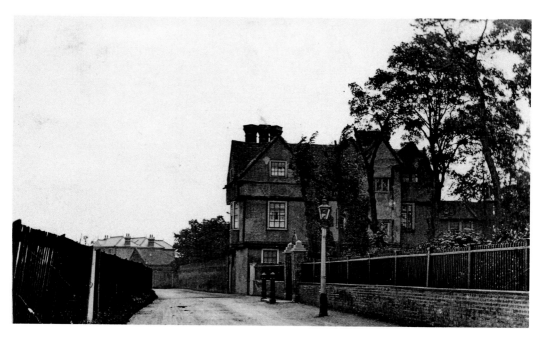

Bury Street West, Bush Hill Park
Salisbury House dates from the late sixteenth century. The house was acquired by the Edmonton UDC in 1936 for £4,500. The houses now opposite Salisbury House were built and first occupied in the early 1930s.

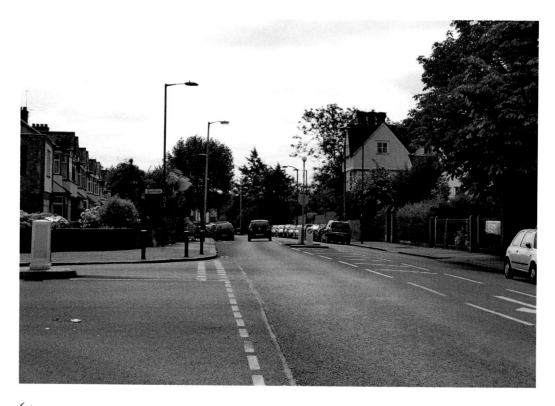

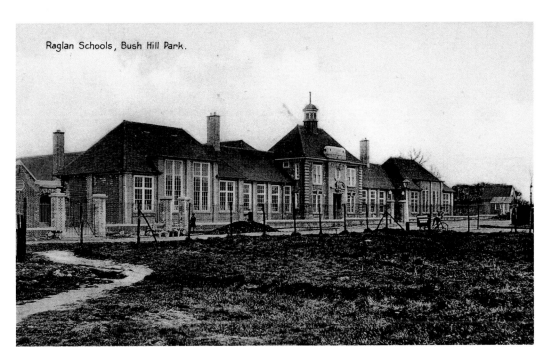

Raglan Schools, Bush Hill Park.

Raglan Road, Bush Hill Park

Raglan School, Raglan Road (Wellington Road right), was opened on 10 March 1928. It was built on the site of one of William Delhi Cornish's brickfields. The first houses in Bagshot Road were built in 1904, but this vacant corner plot was not built on until 1935.

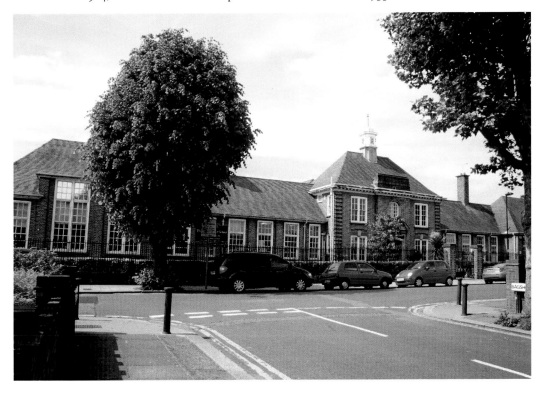

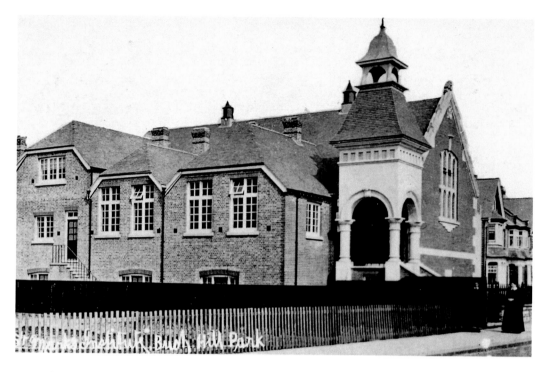

St Marks Road, Bush Hill Park

The foundation stone of St Marks Institute was laid 29 September 1906 and opened on 9 May 1907. The Institute was used as an auxiliary hospital for convalescing soldiers with thirty beds from September 1916, fifty beds from March 1917 and seventy beds from May 1917. It was empty from the 1960s until it was converted into Chapel Court flats in 1985.

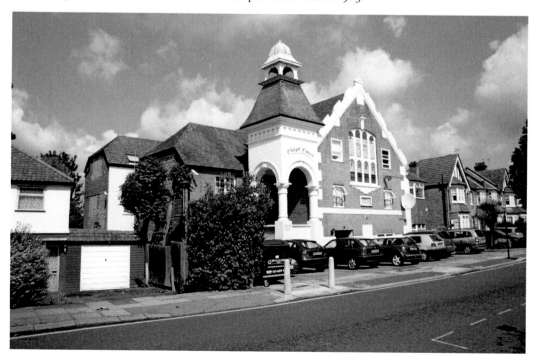

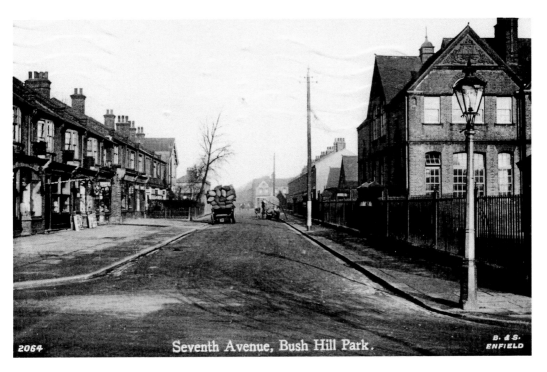

Seventh Avenue, Bush Hill Park

Seventh Avenue, Bush Hill Park

All the properties in Seventh Avenue, except the school, were demolished in the early 1970s. The Bush Hill School first opened its door in June 1896. The far part of Seventh Avenue is now Septimus Place, Bush Hill Park.

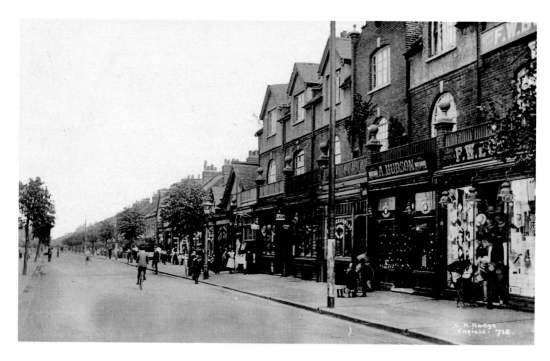

Percival Road, Bush Hill Park

The first plans for nine houses in Percival Road were submitted in July 1885 and the following month for an additional seven shops, to Enfield Local Board of Health. The big difference between the two illustrations is the parked cars.

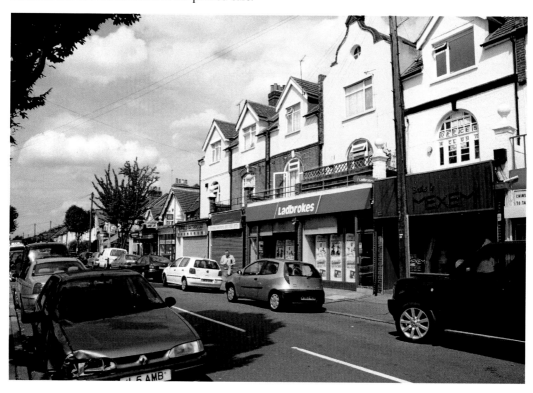

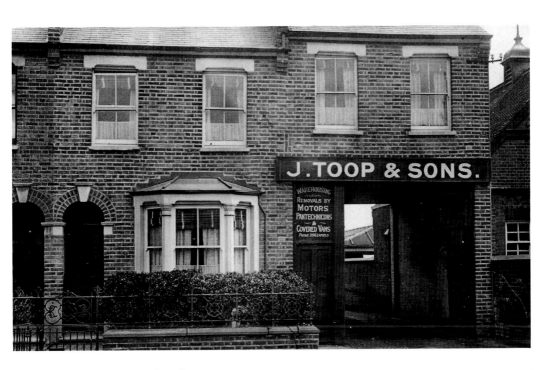

Ermine Side, Bush Hill Park

The school building that abuts now onto Ermine Side, used to be next door to 27 Seventh Avenue. Number Twenty-seven was built 1902 and demolished c. 1973, during the whole of this period it was occupied by the Toop family. The Toops ran their removal business from here.

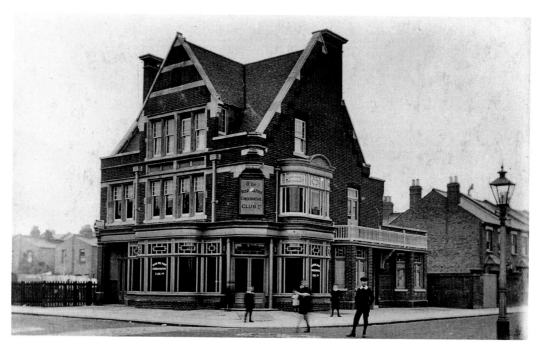

Leighton Road, Bush Hill Park
The Bush Hill Park Conservative Club building is on the corner of Leighton Road and Millais Road. The property was built in 1900.

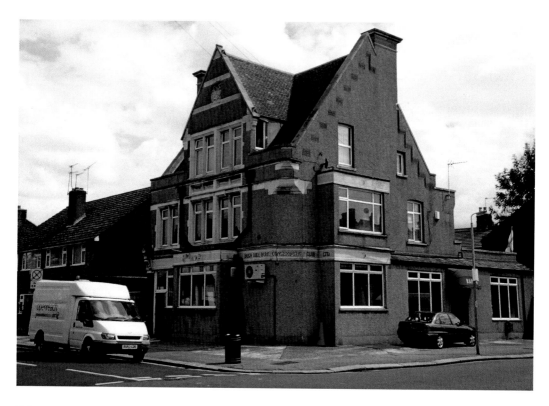

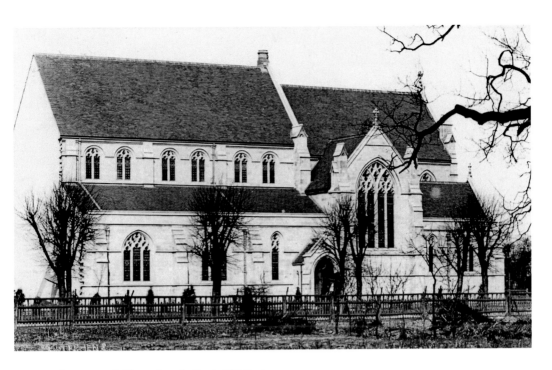

Park Avenue (Village Road), Bush Hill Park
The first part of the present St Stephens Church was started in May 1906 and consecrated in May 1907. The extension (near end) was completed in February 1916. The lych-gate (picture frame) is the church's war memorial, and it was completed and dedicated on 15 January 1922.

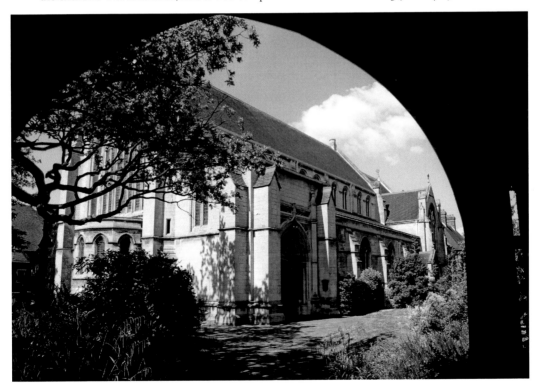

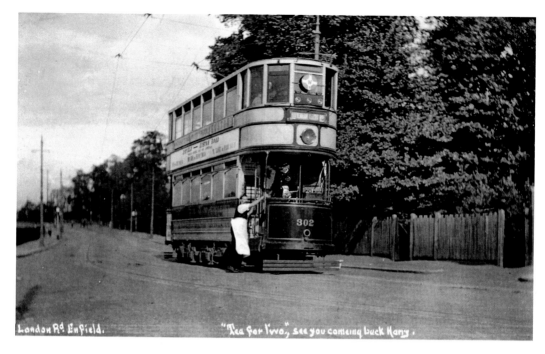

London Rd Enfield. "Tea for Two", see you coming back Harry.

London Road, Bush Hill Park

This is the point where London Road meets Park Avenue (behind the photographer's right). The tram (1909–1938) has come from Enfield Town and is going to Tottenham Court Road. The man with an apron has come from the café that was on the corner Uvedale Road until the late 1950s.

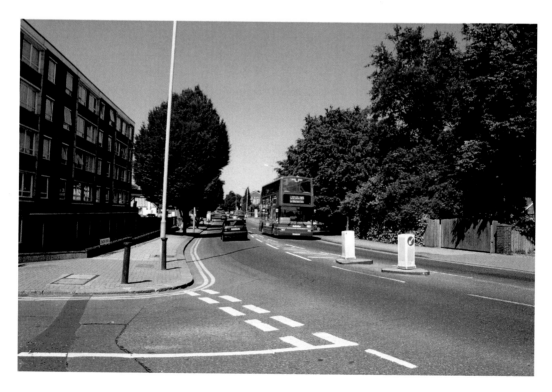

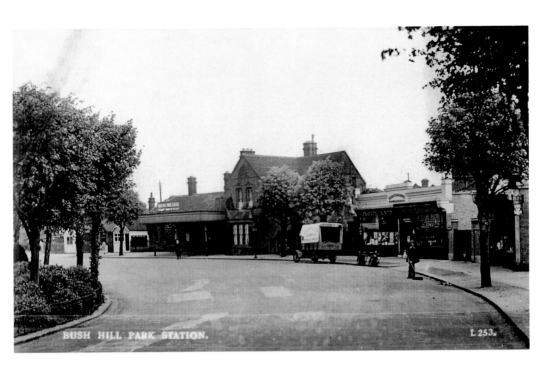

BUSH HILL PARK STATION. L 253.

Queen Anne's Place, Bush Hill Park

The line served by this station came into use 1 March 1849, this station was first proposed October 1872, but didn't come into use until 1 November 1880. This station building was built *c.* 1894, demolished mid 1960s and the present one early 1970s. Queen Anne's Place dates from *c.* 1893. Oakwood Parade was first in use 1928.

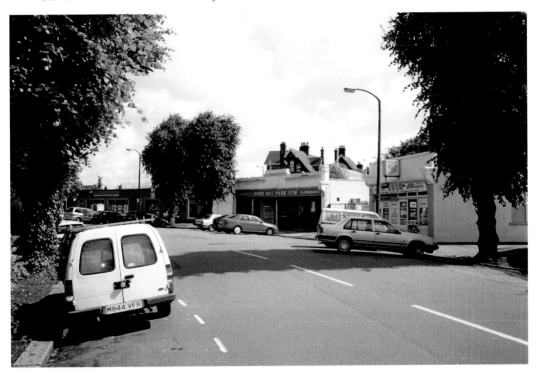

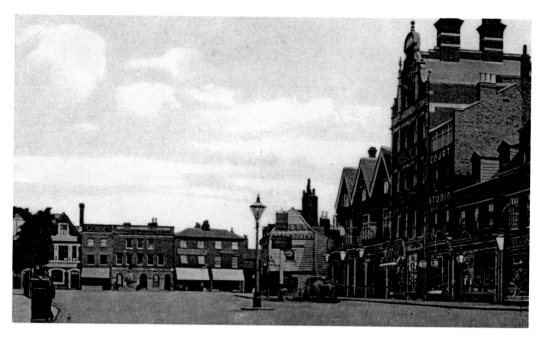

The Town, Enfield

Here we have two contrasting sides, the south that has not changed and the east that has vastly altered. In the middle is the seventeenth century weather boarded building and to its right those that were built in the mid 1890s. The east side has altered at various dates in the last hundred or so years.

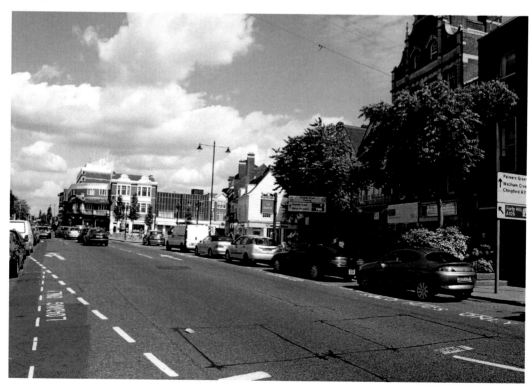

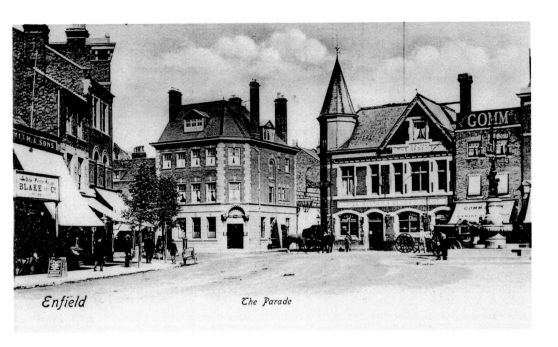

Enfield The Parade

The Town, Enfield

Two halves, the left no change and the right completely altered. In the centre is Lloyd's Bank built 1892, then to the right is Southbury Road. Southbury Road's width has more than doubled today with the rebuilding of the Nags Head public house in 1932, which closed in 1960. This pub is first recorded in 1723 and had been also rebuilt in 1883.

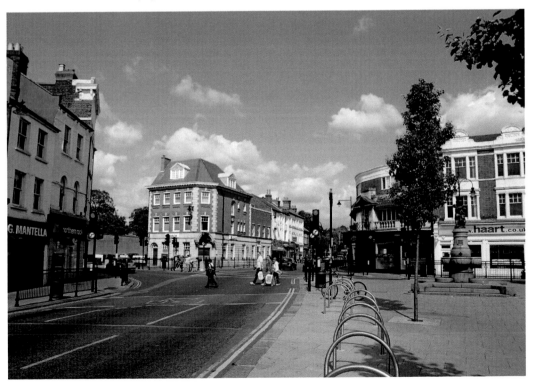

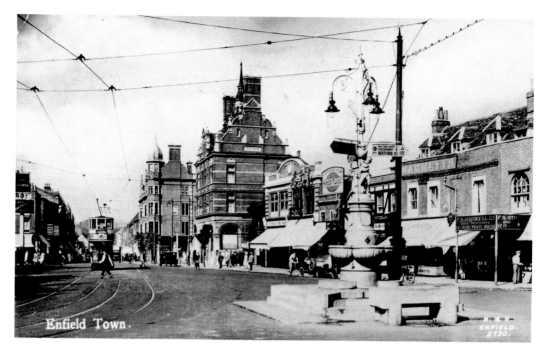

The Town, Enfield

The original picture is later than most in the book, late 1920s. The major change is the building left of Barclays Bank (1897). These are the Tottenham & Edmonton Gas offices that had a short life, built 1914 and replaced in 1937 by the present building.

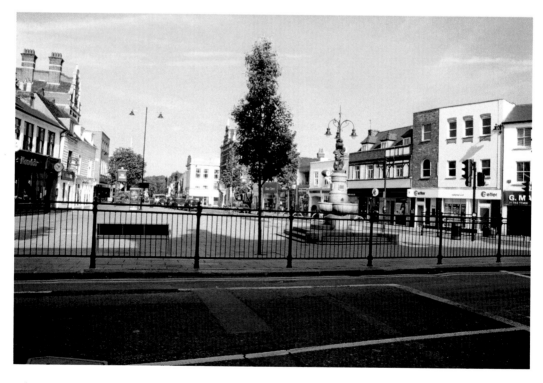

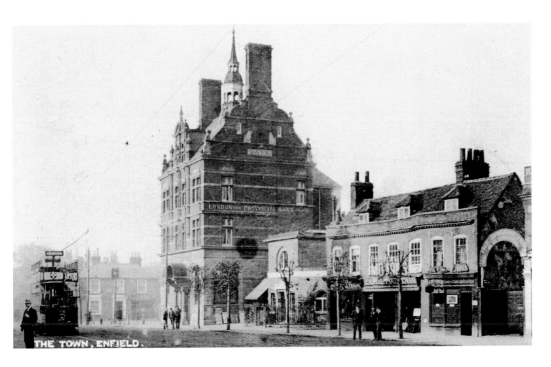

The Town, Enfield

The original picture was taken soon after the tram first came to Enfield Town on the 3 July 1909. Right of the tram we have Barclays Bank built 1897 and then the Vestry Office that dates from 1829. The following buildings were demolished in 1923 and the replacements started being used the following year.

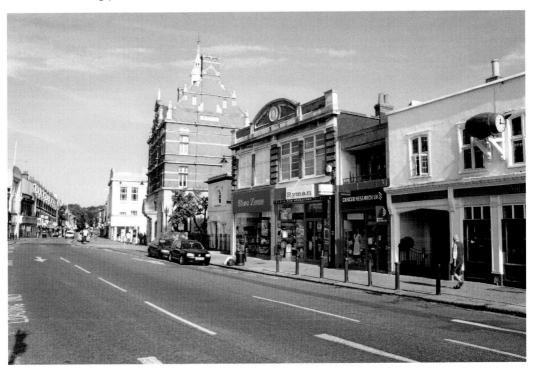

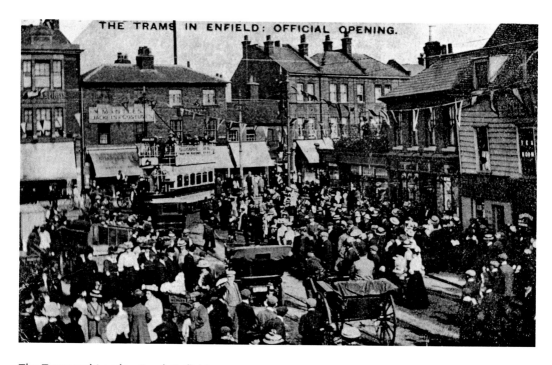

THE TRAMS IN ENFIELD: OFFICIAL OPENING.

The Town and London Road, Enfield
This is Saturday 3 July 1909, the day the first tram came to Enfield. This tram route crossed into the London Borough of Enfield 7 June 1907 as far as Palmers Green and Winchmore Hill 3 June 1908. The trams were replaced by trolleybuses on 8 May 1938.

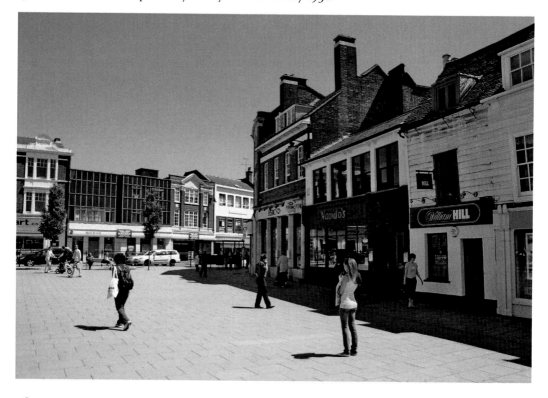

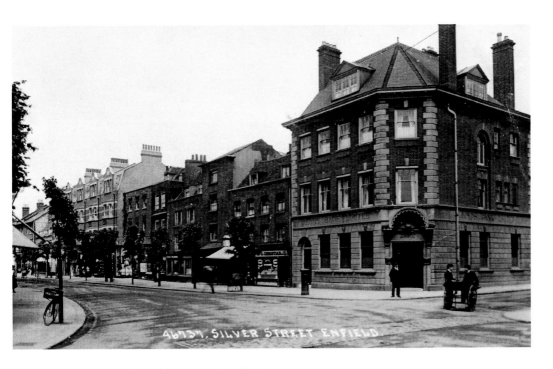

Silver Street and Southbury Road, Enfield

The dominant corner building is Lloyds Bank which dates from 1892. The collection of differing buildings to banks left were demolished in 1964 for a road scheme that never took place. The tall set of buildings that followed the demolition is Town Parade which was built in 1906.

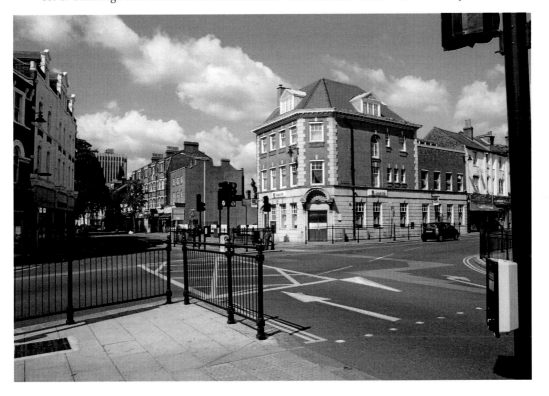

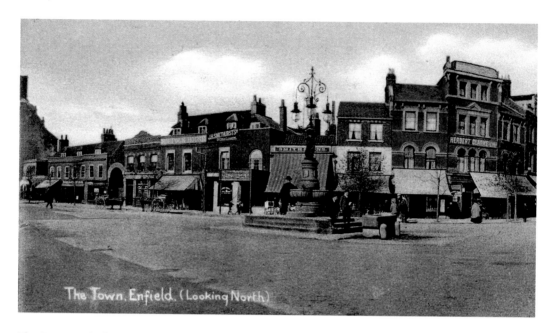

The Town and Silver Street, Enfield

In the foreground is the drinking fountain with a tricorn of lights. It was started in the summer of 1884, but due to a shortage of money, completion was delayed until March 1885. To the right of the fountain is a cattle trough, placed there by the Metropolitan Drinking Fountain and Cattle Trough Association.

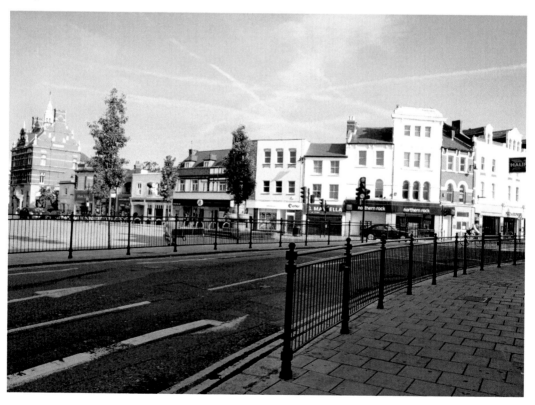

The Town, Enfield

Milton Meyers moved into the property to the right of the George public house in 1894. The property he first occupied can be seen on the October 1903 used postcard, the present day tall building was built in 1897. As well as being a noted printer and bookseller, he was also a photographer, picture framer and stationer. He occupied the replacement building until 1908.

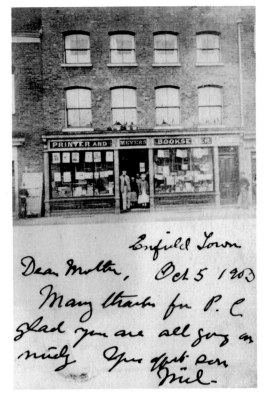

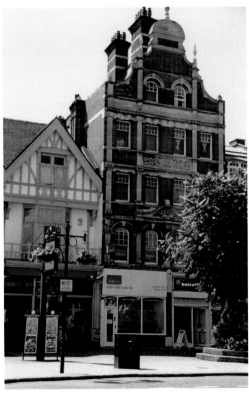

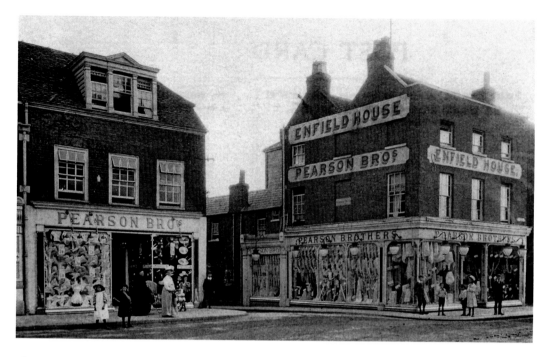

The Town and Sydney Road, Enfield

Here we have Pearson's on both corners of The Town and Sydney Road. Pearson's started trading in the right shop in May 1902, moving to the present one in December 1931. The left one Pearsons used 1907–1921, being bank premises since 1923. Sydney Road used to be called Slaughterhouse Lane and this part of the road is now Hatton Walk.

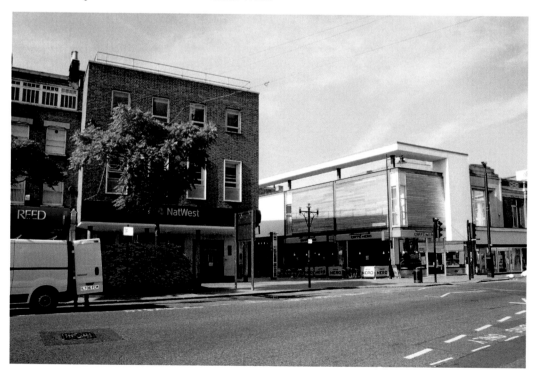

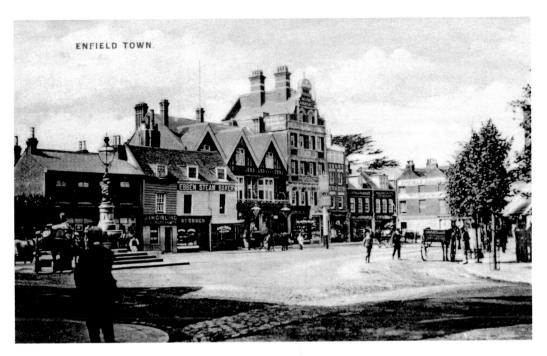

ENFIELD TOWN.

The Town (from Southbury Road), Enfield

The drinking fountain that dates from 1885 has a single lamp, it changed to a tricorn of lamps
c. 1901. The original picture's possible date is limited also by the tall building that was built in
1897. The weather boarded building in the centre is seventeenth century. The one-way traffic
system began in 1970.

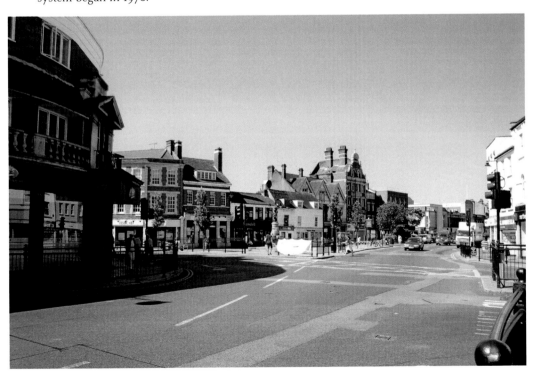

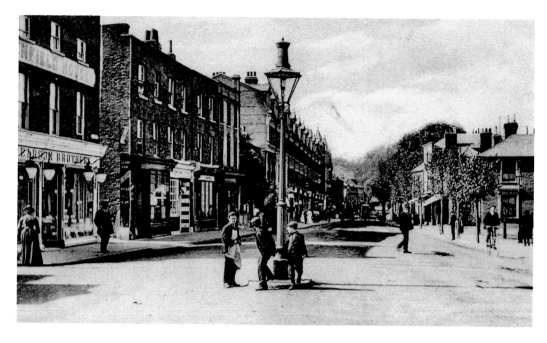

Church Street, Enfield

To the left we have Pearson's where they started trading in May 1902 and where they have been since December 1931. On the corner of the Market Place we have the pre-1914 buildings, beyond these the buildings went up in two phases in 1908 and 1916. The left of centre buildings were first used in the autumn of 1898.

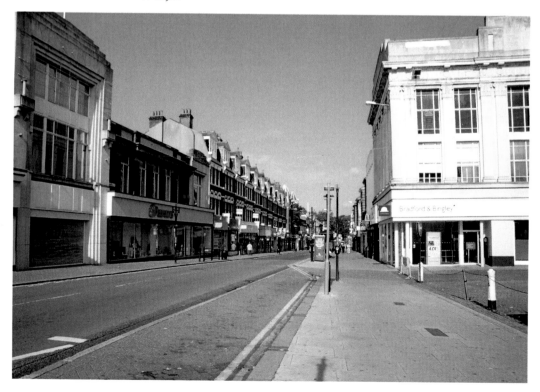

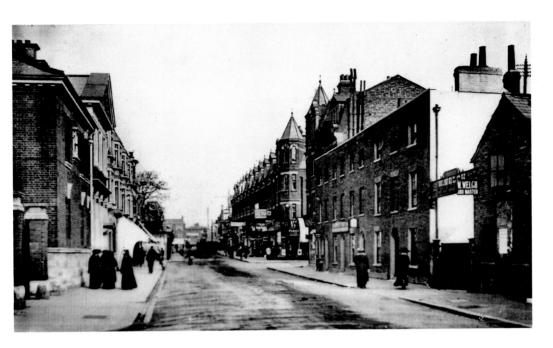

Church Street, Enfield

Here we have on the left the Post Office opened 1905, then the shops and flats built 1908. The near right buildings in the original picture were replaced by those in the present day picture in 1930. Then we have Palace Parade that dates from autumn 1898.

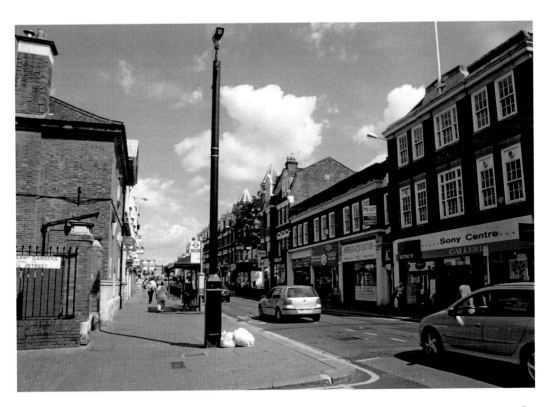

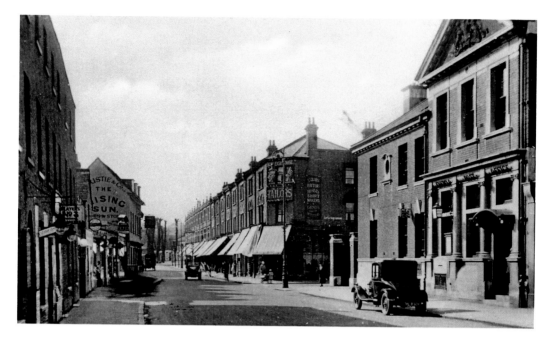

Church Street, Enfield

The near property was replaced in 1930 and the far ones including the Rising Sun public house went in 1934. The Rising Sun which dated from 1736 was demolished as part of the road widening that was necessary. On the right is the Post Office of 1905, the shops/flats that were built in two stages, early 1890s and the far end in 1907.

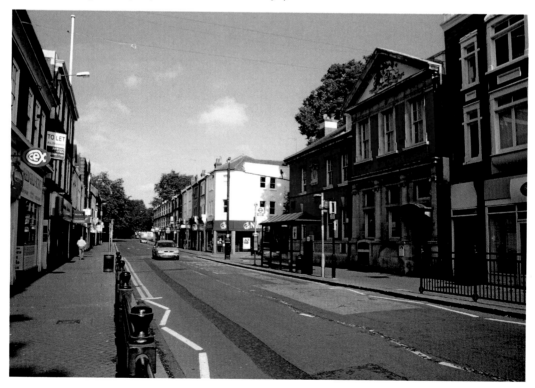

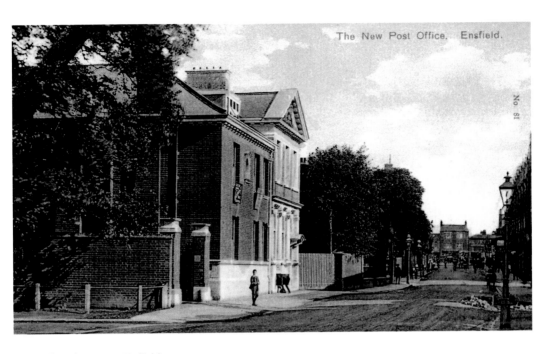

Church Street, Enfield

The old picture is after the Post Office had been opened on the 30 September 1906 and before the first phase of building on its far side happened in 1908. The Post Office was built in the grounds of Percy House, beyond that are trees in the grounds of Burleigh House that was last occupied November 1912.

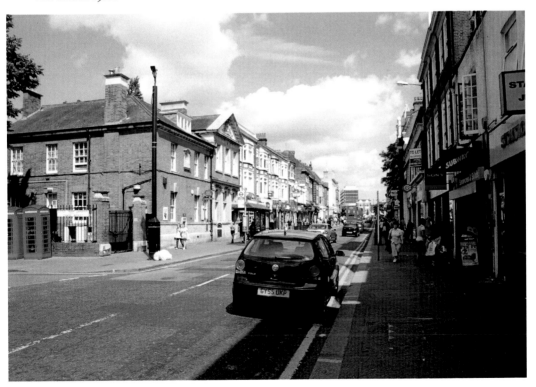

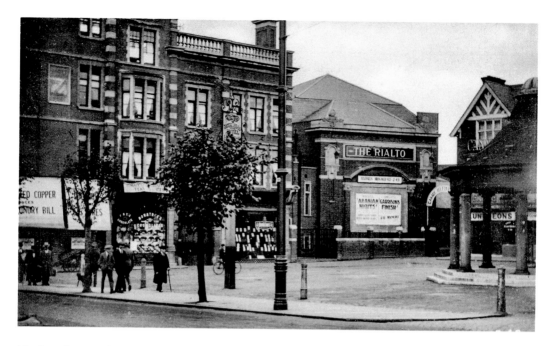

Market Place, Enfield

The films on at the Rialto date the picture to the week starting the 8 October 1923. The cinema opened on the 8 November 1920, renamed the Granada July 1967 and closed on the 17 July 1971. For a period it was a bingo hall, but it has now been empty for a long time. To the left is the Tottenham & Edmonton Gas Co. showroom and offices that were built 1914 and demolished 1937.

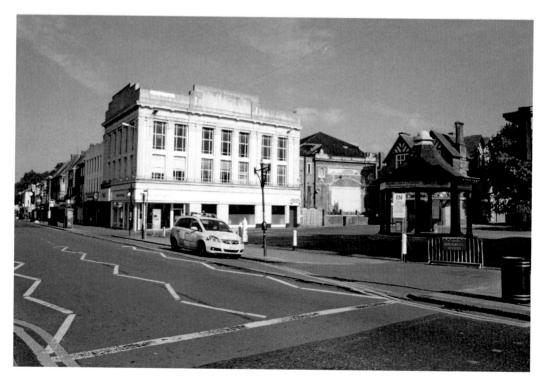

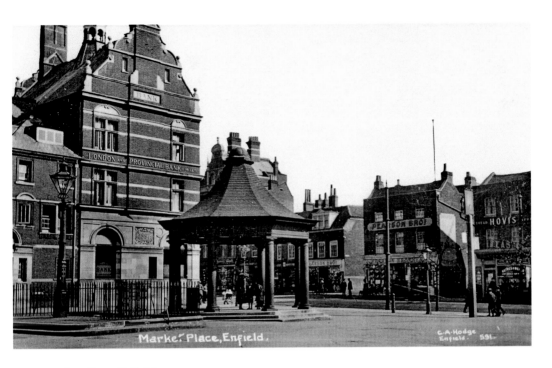

Market Place, Enfield

Left of the Market House is London Provincial Bank that became Barclays in 1918. Also on the left is a set of railings, this was for underground toilets that were in use from *c.* 1902, to the early 1950s. On the right of the Market House is Pearson's of 1902 and since 1931. To the rear of the red car is a cast iron pump that was in the Market Place 1847 to 1904, but was returned in May 1979.

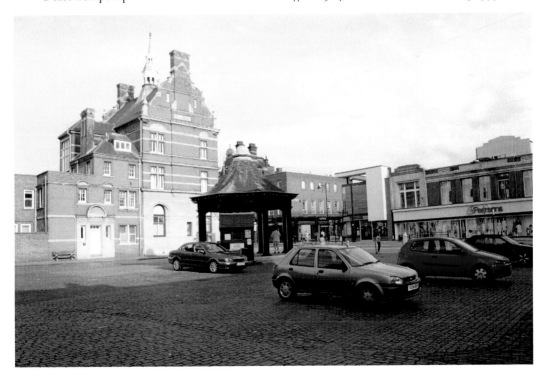

London Road and Cecil Road, Enfield
There were Baptists in Enfield in the
seventeenth century, but this, their first church
was not built till 1875 in London Road. They
moved to their present church in Cecil Road in
1926. The London Road property was used by
Woolworth's from 1926 until they replaced it
with the present building in 1958.

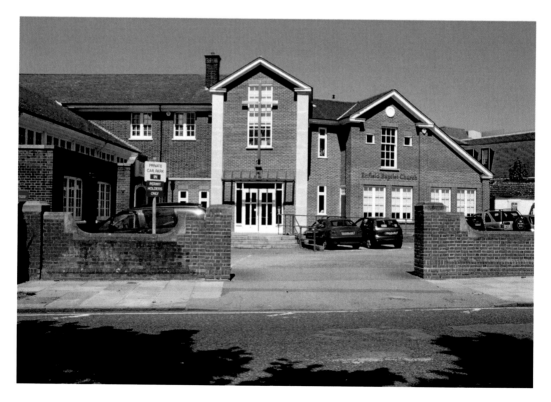

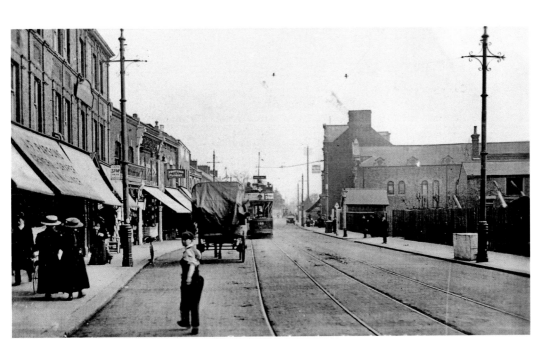

London Road, Enfield

The left and far right sides have not changed in these views. In the mid-distance-right is the Baptist/Woolworth's building referred to before. The near right side was demolished 1908 to widen the road for the tram service that started the following year. The Palace Xchange precinct's shops opened just before Christmas 2006, replacing a single-storey building on the near right side.

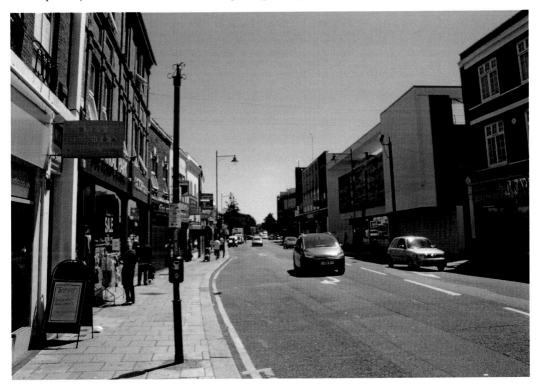

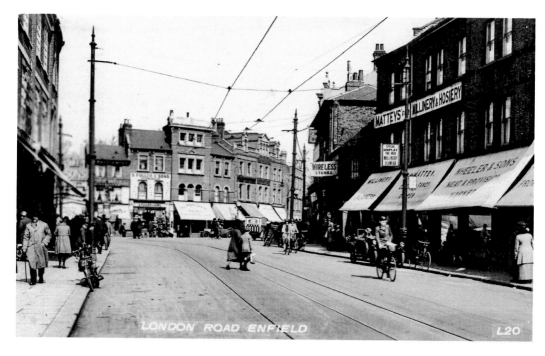

London Road, Enfield

The only buildings that have changed from the late 1920s view are on the far right. These changes were in the mid twentieth century. These tramlines were in use between July 1909 and May 1938, replaced by trolleybuses which lasted till April 1961.

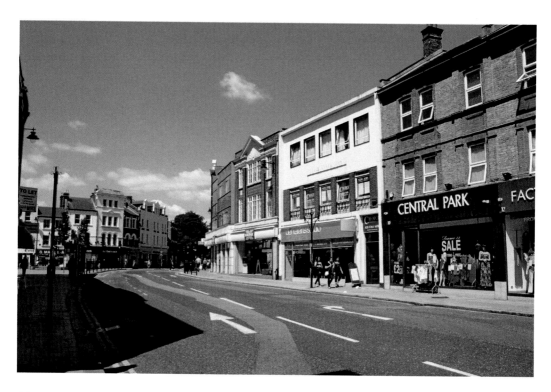

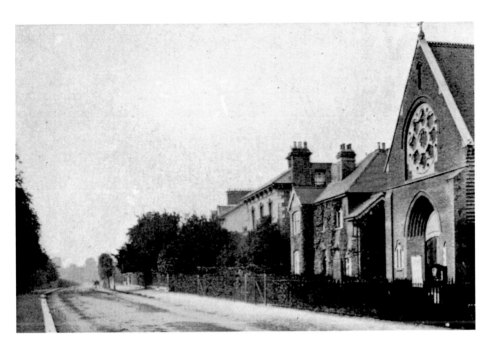

London Road, Enfield

On the right the first Roman Catholic Church, Our Lady of Mount Carmel and St George. Its foundation stone was laid in September 1900 and the first service was April 1901. The current Roman Catholic Church opened on 2 July 1958, replacing the previous one which had been unusable since the bombing of the 15 November 1940.

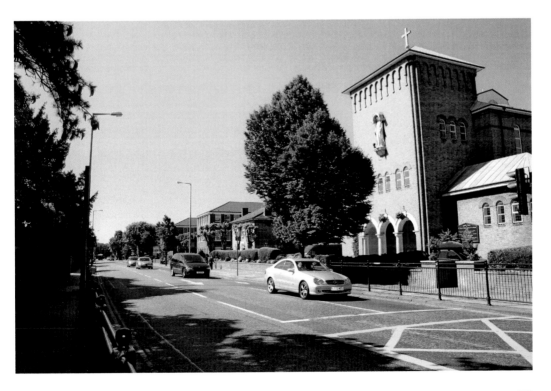

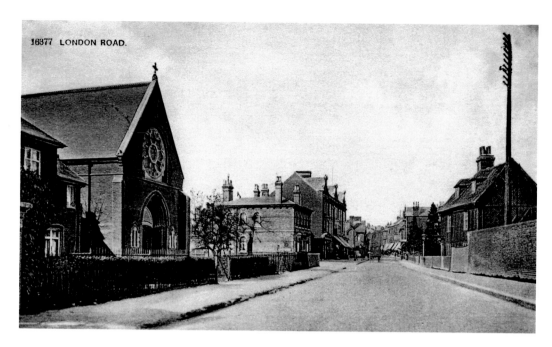

16377 LONDON ROAD.

London Road, Enfield

The first difference between these pictures is the original photographer could take the picture in the middle of the road, with no danger at all. These pictures are in the opposite direction of the previous ones. The new church is south of the site of the old one. The next building on the left, on the far corner of Cecil Road, was Enfield's Police Station 1872–1965, that was replaced in 1984.

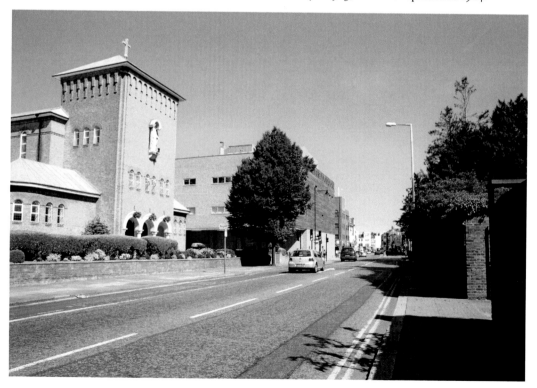

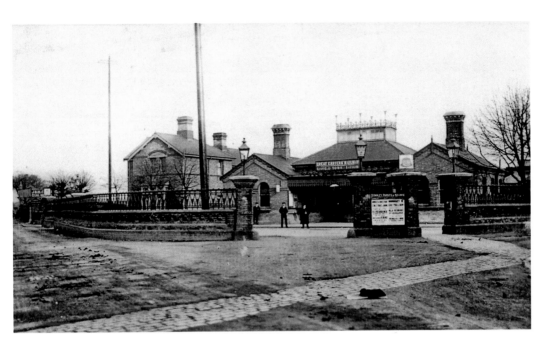

Southbury Road and Genotin Road, Enfield

The first Enfield Town station opened on this site 1 March 1849. We have pictured the second that was first used on the 1 August 1872 and the present day one that was officially opened 25 April 1958. The station was when first opened on the corner of Nags Head Lane (Southbury Road from 1882) and Station Road (Genotin Road in the 1870s).

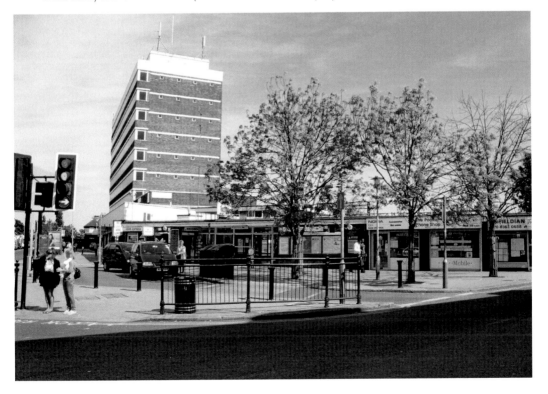

River Front, Enfield
This view on the corner of River Front and St Andrew's Road has changed more than any other in the book. The road's one claim to fame is that the fifth property from the left was occupied by the Dugdale family 1890s–1950s, and Florence Dugdale was the second wife of the author Thomas Hardy. They married in St Andrew's Church, Market Place, Enfield on 10 February 1914.

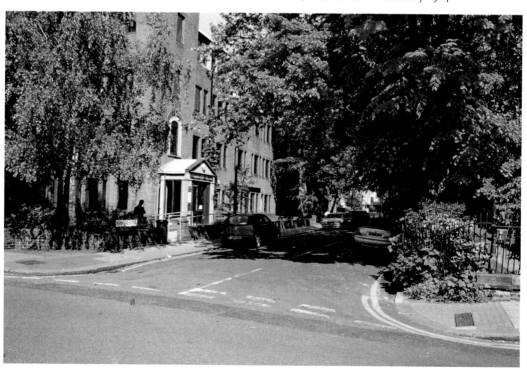